IMAGES
of America

UPPER
BEACON HILL

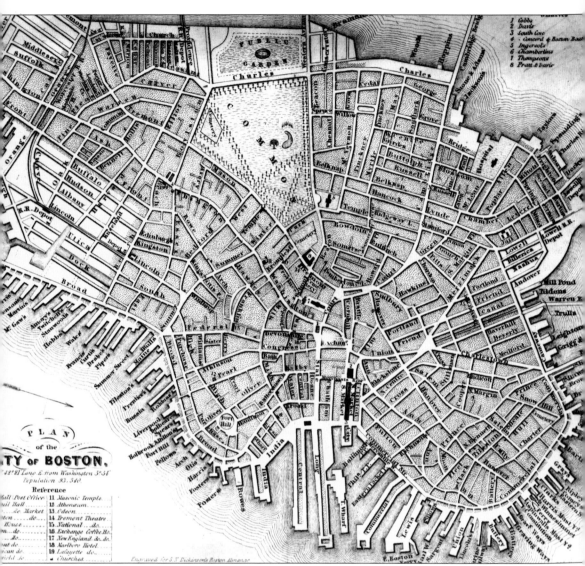

This mid-19th-century map shows upper Beacon Hill's past and current streets. Bordered on the west by Park and Temple Streets, the area is encircled by Cambridge Street to the north, which joins Tremont Street on the south as it passes Park Street. The Boston Common, in the center of the upper half of the map, can be used to locate the area since it adjoins Park Street on its eastern edge. (Courtesy of the Bostonian Society.)

IMAGES
of America

UPPER
BEACON HILL

Rhea Hollis Atwood

ARCADIA

First printed in 2002.

Published by Arcadia Publishing,
an imprint of Tempus Publishing, Inc.
2A Cumberland Street
Charleston, SC 29401

Printed in Great Britain.

Library of Congress Catalog Card Number: 2002108564

For all general information contact Arcadia Publishing at:
Telephone 843-853-2070
Fax 843-853-0044
E-Mail sales@arcadiapublishing.com

For customer service and orders:
Toll-Free 1-888-313-2665

Visit us on the internet at http://www.arcadiapublishing.com

To Becca, Ann, Douglas, and their families.

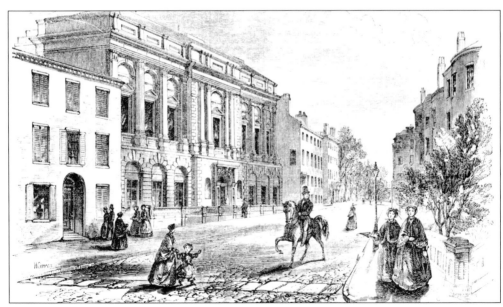

This 1850s view of the Boston Athenaeum's exterior was found in *Ballou's Pictorial Drawing Room Companion*. The dignity and elegance of the institution set a precedent for the atmosphere of upper Beacon Hill. The image is depicted in Catherina Slautterback's 1999 book *Designing the Boston Athenaeum: 10^1/$_2$ at 150*. (Courtesy of the Boston Athenaeum.)

CONTENTS

ACKNOWLEDGMENTS

Special thanks go to the Boston Public Library Print Department and Aaron Schmidt of its Photography Collection; Boston Photo Imaging, Carol Smith president; and Suffolk University for making this book possible.

This book grew out of a brief history written for the Beacon Bellevue Civic Association under the direction of its president, Billie Lawrence, whose support and advice in the preparation of this book have been invaluable. This volume could not have been put together without the help of the following: Susan Lewis, Boston Architectural Center; Sally Pierce, Boston Athenaeum; Nancy Richard, Bostonian Society; Brenda and Steve Ellis, Church of the New Jerusalem; Hal Worthley, Congregational Library; Allan Goodrich and James Hill, Kennedy Library; Laura Condon and Rebecca Aaronson, Society for the Preservation of New England Antiquities; Betsy Lowenstein, State Library of Massachusetts; and Robert Allison, Suffolk University Archives. Additional thanks for their contribution are also extended to the Self-Realization Fellowship Archives in Los Angeles and to Dr. Michael C. Stone and J.V. Weston for the use of their private collections. A debt of gratitude goes to editorial assistant Rachael Gabriel for her valuable input and long hours of work. Particular thanks go to my editor, Jill Anderson, for her guidance and infinite patience. I am very grateful to the many members in the upper Beacon Hill community who have given of their time and abilities: Magdalene Cullen, Ora Damon, Brenda and Steve Ellis, Mannie Greenspan, Gary Hammer, Billie Lawrence, Harry Schoenbrun, and the employees at the Beirut Restaurant, the Capital Coffee Shop, and Fill-A-Buster restaurant. Friends and coaches Janet Becker, Doug Glener, Sandra Gray, Floyd Kemske, and Marcia Yudkin complete this list of acknowledgments.

INTRODUCTION

Upper Beacon Hill brings to life this small, diverse community's colorful history and powerful influence from 1850 to 1950, material often hidden to residents and visitors alike. Obscured by Beacon Hill's elegant and fashionable southwestern slope, an area predominantly the scene of many handsome Federal homes and patrician families, upper Beacon Hill as a neighborhood lies largely unexamined.

Its early history dates to descriptions of the Boston peninsula of the 1630s containing Trimountain, a mountain with three hills on top: Pemberton, Beacon Hill, and Mount Vernon. Of this region, only Beacon Hill in its greatly reduced state remains. The area was unsettled until the 1700s, but a court decree did order a beacon to be placed on its highest peak, later called Beacon Hill, to warn the colonists of approaching danger. The early 18th century saw the erection of handsome mansions on remote upper Beacon Street belonging to French Huguenot Faneuil and wealthy merchants Ewing and Bromfield. During the turbulent years of the American Revolution, festive entertaining of French naval officers and others loyal to the patriot cause took place daily at the stately home of John Hancock. Later, nearby Gov. James Bowdoin's mansion was occupied by British general "Johnny Burgoyne." The years following the war saw rapid transformations in the community. Architect Charles Bulfinch's Massachusetts State House, completed in 1798 with its later copper-clad dome by Paul Revere, won instant national recognition as a symbol of the new republic's emerging power and excellence. It also created a barrier, separating Beacon Hill's lower, western slope from the area covered by this book—a separation later reinforced by the amassment of government buildings, churches, and institutions in upper Beacon Hill. Bulfinch's Amory-Tichnor house and other nearby dwellings, plus Bulfinch's work in enforcing the uniformity of buildings near the Massachusetts State House, were crucial steps in transforming upper Beacon Hill. The ambitious Mount Vernon Proprietors, established in 1795, removed land from the area's peaks for profitable creation of new lands—a move that forever changed the topography of the area. Historian Walter Muir Whitehill's phrase "cutting down the hills to fill in the coves" has its origin here.

It was the early 1800s that saw the emergence of brick bowfront houses and sidewalks lining Beacon and Somerset Streets and nearby Pemberton Square, giving Beacon Hill its classic charm. Upper Beacon Hill's merchant princes thrived, and the area as a whole assumed its identity as a 19th-century enclave based on rigid family structure and material wealth. Interrupted only by the War of 1812, the neighborhood's progress continued.

The building of the Boston Athenaeum in 1849 at 10¹/₂ Beacon Street, originally a private library and now the country's largest independent membership library, exerted a strong and lasting cultural influence on the community. It also attracted scholars, writers, and researchers from all over the world. Philosophy and literature flourished on upper Beacon Street in the mid-19th century as Louisa May Alcott, Ralph Waldo Emerson, and Henry Wadsworth Longfellow formed a literary salon in the old Hotel Bellevue. A member of the Transcendentalist movement, James Freeman Clarke, minister of the Church of the Disciples, was also active in the abolitionist and suffragette causes. Waves of new religious thought swept through this neighborhood so near the harbor, a center for news from Europe and the East. King's Chapel, the first Unitarian church in Boston, was joined by the Unitarian Church of the Disciples, which was later occupied by Boston's first French-speaking Roman Catholic church, Notre Dame des Victoires. The First Baptist Church crowned the crest of Somerset Street, and one of the earliest Swedenborgian churches in America was established on Bowdoin Street. The American Congregational Association was established in 1898 to further the activities of this successor to New England Puritanism. Activity in women's increased role in society took place here as women were active in abolitionism, the suffragette movement, and literary activities, as well as in the establishment of women's clubs. An emphasis on education saw the early establishment of Boston University, English High School, and the opening of Suffolk University in this neighborhood.

The Civil War years were marked by many sacrifices by the area's men. Col. Robert Gould Shaw, son of a local Brahmin family, can be seen in Beacon Street's Augustus Saint-Gaudens memorial. Here, he leads men of the 54th Massachusetts Infantry into battle at Charlestown, South Carolina, where Shaw and many of his men, who were mostly African Americans, were killed.

Another important influence entered upper Beacon Hill in the mid-19th century. Ireland's potato blight of 1846 sent waves of Irish immigrants to Boston—the year 1847 saw 37,000 Irish arrivals to Boston. Many of these families settled on upper Beacon Hill's eastern slope near Scollay Square, a large center for Boston's growing transportation system. Alarmed by this influx, many wealthy Brahmin families whose values were based on social class and money left affluent Pemberton Square and comfortable homes on Somerset Street and Ashburton Place for Beacon Hill's western slope and the newly developed Back Bay. The vitality, strength, and leadership of these new Americans would later be evident in the emergence of men like John F. Kennedy. Rooming houses and boardinghouses followed the exodus, although it should be remembered that initially, most were quite respectable and some were even run as literary salons. Scollay Square became a center of inexpensive entertainment for area residents, although by the 1940s, city planners decided that it had become a blight and ordered the razing of Scollay Square in 1962. It was replaced by the new Government Center.

The Massachusetts State House remained a center of power and influence in the community as men and women from around the world visited its halls. The elegant Hotel Bellevue on Beacon Street, designed in 1899 by Peabody and Stearns, opened another chapter in this sophisticated community. Boasting the city's first hotel passenger elevator, the city's first café, and first 24-hour telephone system, it attracted national and local notables as its guests. Scientist Alexander Graham Bell, writer Louisa May Alcott, former mayor John F. Fitzgerald, and John F. Kennedy lived here, while aviator Charles Lindbergh was feted here after his Atlantic triumph. Scores of politicians from the nearby statehouse frequented the Bellevue Pub, and later, the hotel's Golden Dome pub, which wags called the State House Annex.

Upper Beacon Hill affords the readers many more glimpses into this community and serves as as reflection of America's accomplishments, challenges, and triumphs over the century. The ability of the neighborhood's institutions to maintain their high standards has enabled upper Beacon Hill to continue its role as a leader. Through the following photographs, enjoy this unusual community's dramatic role in history and revel in its uniqueness.

One

CELEBRATIONS

AND FESTIVITIES

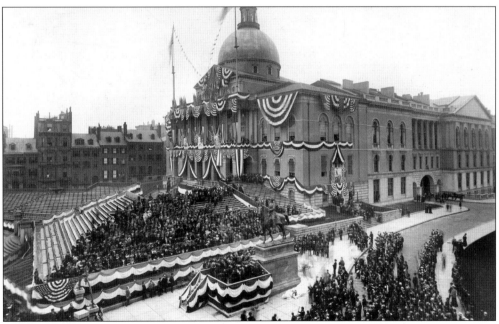

This statue of popular Union Civil War leader Gen. Joseph Hooker, created by Daniel Chester French, was dedicated on the Massachusetts State House grounds in 1903 with much display of bunting and ceremony. While the statue was being completed, Hooker lost the important battle of Chancellorsville in Virginia. However, his military record was so outstanding that orders were given for the statue to be finished in spite of his defeat. The statue remains on the statehouse lawn today. The photograph gives an excellent view of the long addition to the rear of the statehouse by architect Charles E. Brigham (from 1885 to 1889). (Courtesy of the Boston Public Library.)

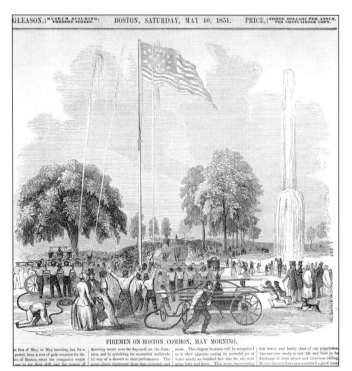

GLEASON, | MUSEUM BUILDING, TREMONT STREET. BOSTON, SATURDAY, MAY 10, 1851. PRICE, | THREE DOLLARS PER ANNUM, TEN CENTS SINGLE COPY.

FIREMEN ON BOSTON COMMON, MAY MORNING.

May 1, a popular mid-19th-century Boston holiday, was an occasion for festive competition among the city's firemen. This 1851 illustration from *Gleason's* magazine shows firefighters' engines on the Boston Common, pumping jets of water 100 feet in the air in an effort to throw water over the Boston Common's flagstaff. The eager crowd enjoyed the resulting sprinkling, which was sure to follow. (Courtesy of the Boston Public Library.)

The Boston Water Celebration, a tinted lithograph dated October 25, 1848, and printed by J.H. Bufford, shows the procession of the Great Water Celebration passing by the Boston Museum on Tremont Street. The Moorish arch designed by Boston architect Hamett Billings adds an exotic air. These festivities marked the introduction of a new public water supply piped into the city from Lake Cochituate in Framingham. (Courtesy of the Boston Athenaeum; photograph from *Boston Lithography*, by Pierce and Slautterback.)

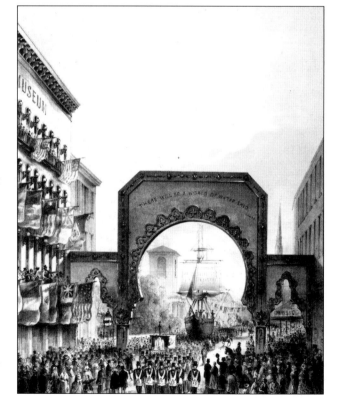

10

The Union Club, an 1805 building located at 8 Park Street, is shown in this June 17, 1875 photograph in full patriotic regalia for the centennial celebration of the Battle of Bunker Hill. According to local stories, the Union Club established itself as a club separate from the Beacon Street Somerset Men's Club during the Civil War after allegations were made about possible lucrative business dealings with the Confederacy by some Somerset Club members. The Union Club maintains a strong cultural and social role in upper Beacon Hill today. (Courtesy of the Boston Public Library.)

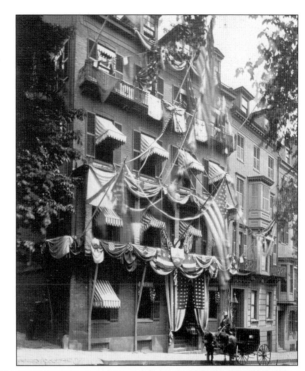

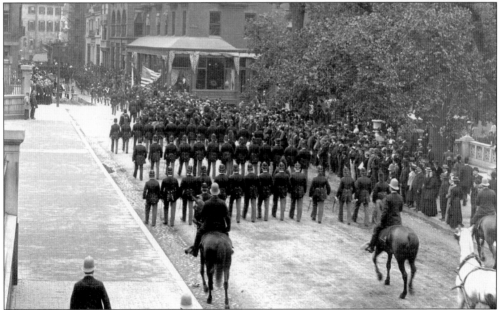

The Ancient and Honorable Artillery Company of Massachusetts is on parade on Beacon Street in front of the Massachusetts State House in this 1900 photograph. Founded in 1637 by Gov. John Winthrop to defend to the colonists against Native American attacks, the group still holds an annual meeting on June Day, accompanied by a procession and festivities. They conduct commissioning ceremonies on the Boston Common to the echoes of cannon fire. The company currently operates a military museum in Faneuil Hall and counts John F. Kennedy among its notable members. (Courtesy of the Boston Public Library.)

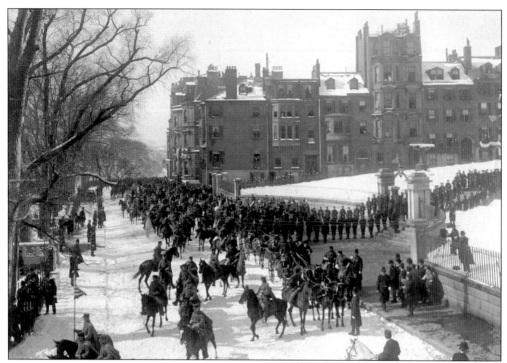

Prince Henry of Prussia leaves the Massachusetts State House, stepping into an elegant carriage, in this 1903 photograph, which depicts the era's love of pomp and circumstance. (Courtesy of the Boston Public Library.)

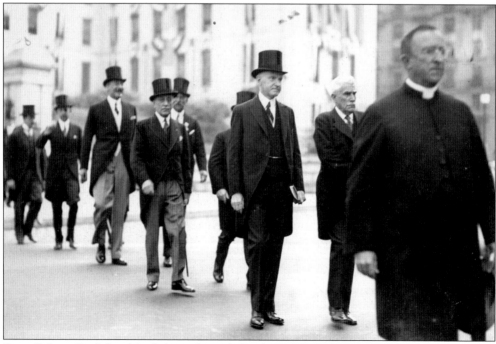

Pres. Calvin Coolidge (third from the right) takes part in the Massachusetts tercentenary celebration. (Courtesy of the Boston Public Library.)

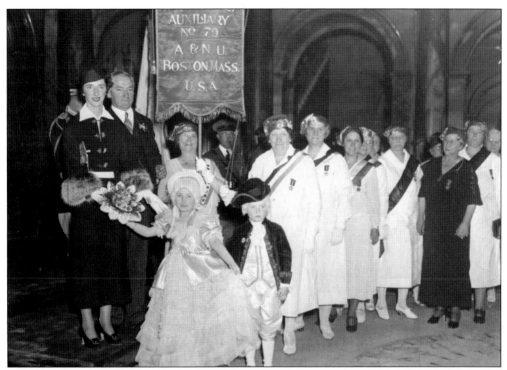

George and Martha Washington greet Gov. James Michael Curley and his wife, Mary, in this 1935 photograph published in the *Boston Herald*. The children are five-year-old Charles F. Knapp Jr. of Roxbury and six-year-old Eileen Greene of Dorchester—cousins who are grandchildren of Agnes B. Knapp, who is standing directly behind them. She was commander of the Mary E. Curley Auxiliary No. 79, Army and Navy Union. (Courtesy of the Boston Public Library.)

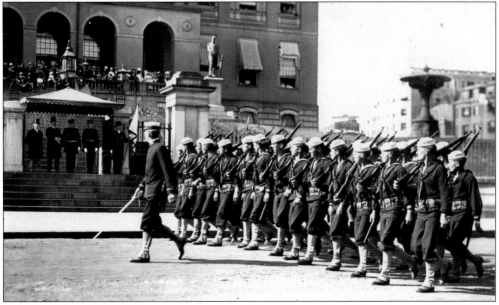

Flag Day, June 16, 1913, brings troops to parade in front of the Massachusetts State House. (Courtesy of the Boston Public Library.)

13

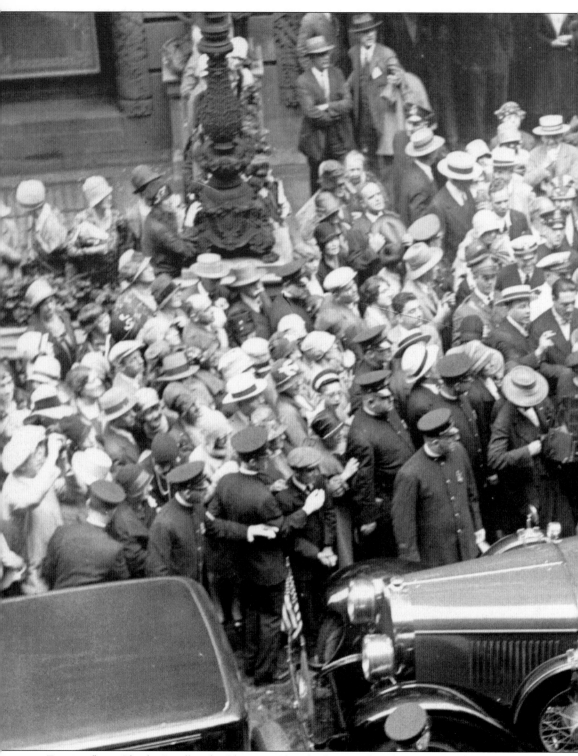

Famous flyers Charles Lindbergh, Clarence Chamberlain, and Richard E. Byrd arrive in 1927 at the Hotel Bellevue, located at 19–25 Beacon Street, for a celebration breakfast. (Courtesy of

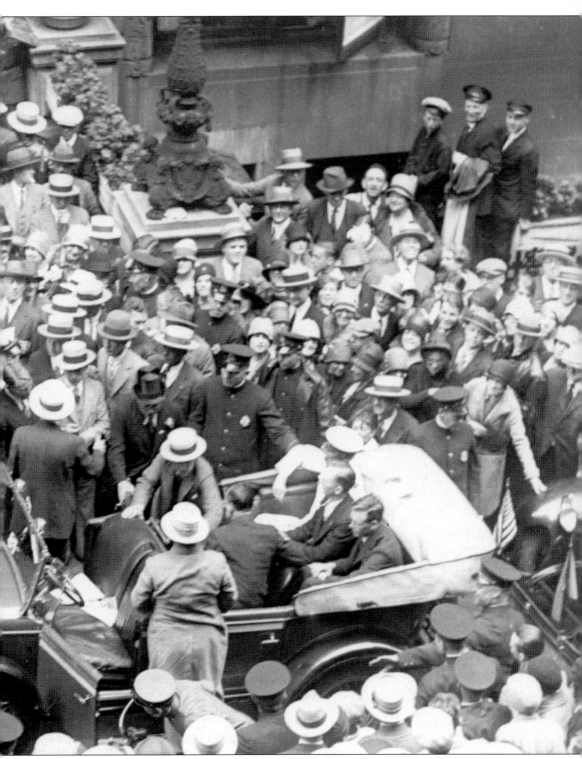

the Boston Public Library; photograph by Leslie Jones.)

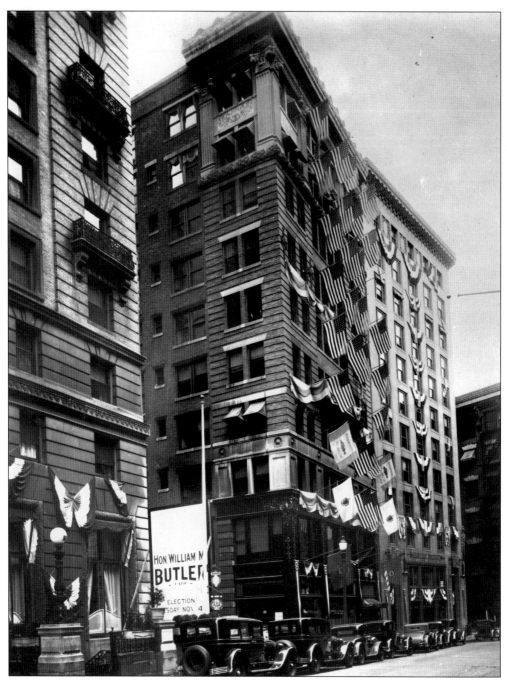

Upper Beacon Street celebrates Boston's tercentenary in 1930. The flag-decked building in the photograph's center, at 15 Beacon Street, is an office building designed in 1903 by Boston architect William G. Preston. In 1998, owner Paul Roiff converted it into Hotel XV Beacon. This small, elegant European boutique hotel, in which each room is equipped with state-of-the-art communication technology, contains a neighborhood favorite, the Federalist restaurant. The Hotel Bellevue is to the left of the building, and on the right is the Lawyer's Building. (Courtesy of the Bostonian Society.)

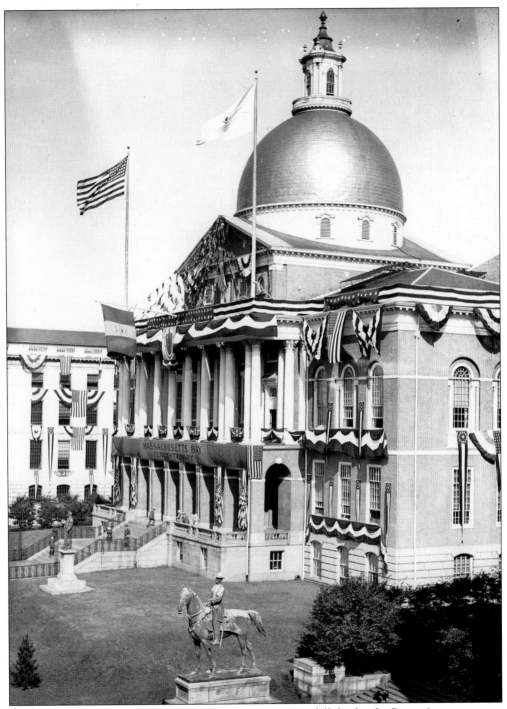

This 1930 image shows the Massachusetts State House in full display for Boston's tercentenary celebration. (Courtesy of the Boston Public Library; photograph by Leslie Jones.)

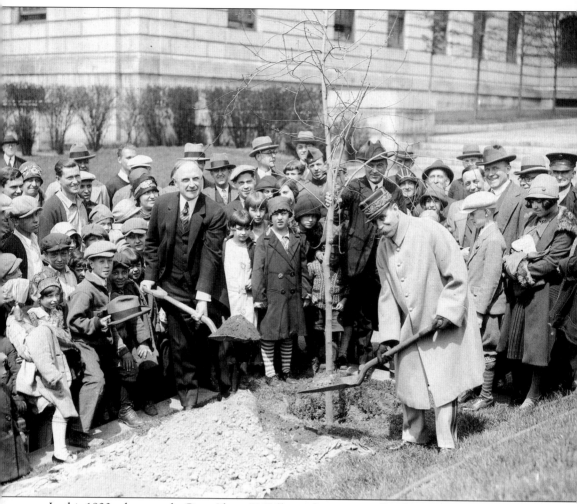

In this 1920s photograph, Gov. Alvan T. Fuller and a visiting official are shown planting a tree for Arbor Day, a popular New England holiday. (Courtesy of the Boston Public Library.)

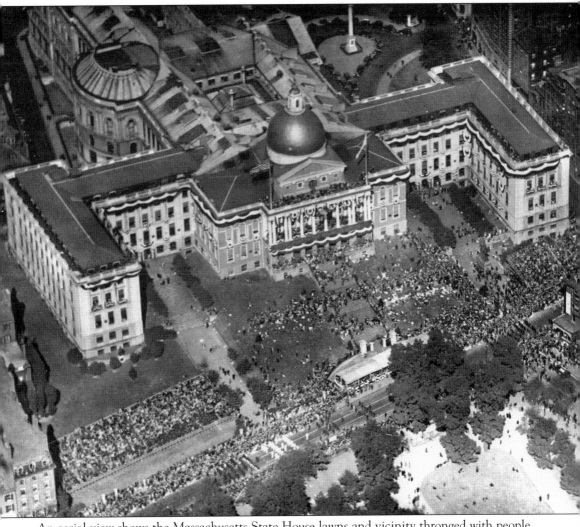

An aerial view shows the Massachusetts State House lawns and vicinity thronged with people attending the large 1930 American Legion parade celebrating the tercentenary. (Courtesy of the Boston Public Library.)

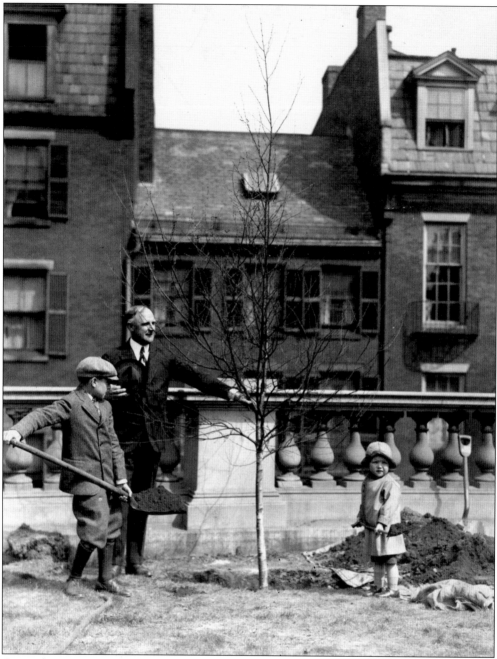

Gov. Alvan T. Fuller and his two sons, eight-year-old Alvan and three-year-old Peter, plant a tree on the Massachusetts State House lawn for Arbor Day in this 1926 photograph. Brick houses of Derne Street are seen in the background. (Courtesy of the Boston Public Library; photograph from the *Boston Traveler*.)

20

Two

BRIEF HISTORY

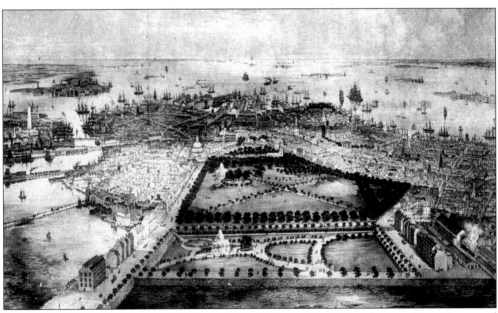

This 1850 lithograph gives us a bird's-eye view of Boston. The Massachusetts State House and roofs of upper Beacon Hill are to the upper left and north of the Boston Common. The Park Street Church can be found in the center of the image near the north edge of the common. (Courtesy of Dr. Michael C. Stone.)

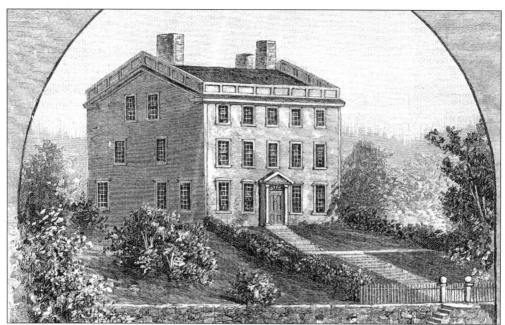

A woodcut made in 1845 shows the Edward Bromfield mansion , which was built in 1722. It is said to be the first dwelling built on Beacon Street. Located opposite the future Boston Athenaeum, it was next occupied by Bromfield's son-in-law William Phillips. Phillips's daughter Abigail married Josiah Quincy Jr., the American Revolution patriot. The Bowdoin mansion, home of Governor Bowdoin, a Huguenot descendant, was to the left of the Bromfield mansion. A third large house, the Sears mansion, was on its right. (Courtesy of the Boston Athenaeum.)

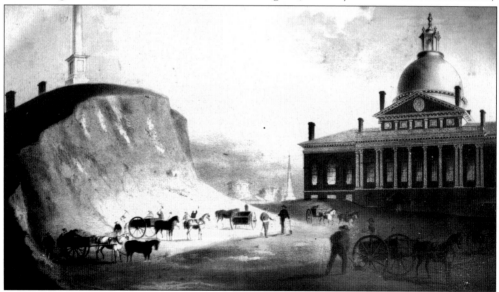

This late-18th-century lithograph faces the rear of the Massachusetts State House from the future Beacon Hill Reservoir site. The digging down of Beacon Hill was undertaken to provide fill for new construction throughout the city, or, in the words of historian Walter Muir Whitehill, the digging down was "cutting down the hills to fill in the coves." (Courtesy of the Bostonian Society.)

Gov. John Hancock's mansion, near the Massachusetts State House, is shown here prior to its destruction in the 1850s. Once the scene of generous hospitality for the French naval officers and others loyal to the patriot cause during the American Revolution, it served as an example of the new republic's high standards. (Courtesy of Dr. Michael C. Stone.)

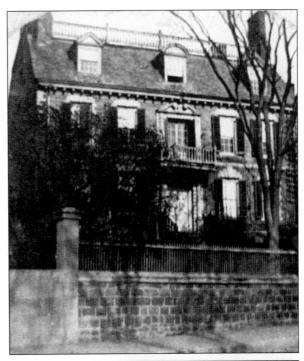

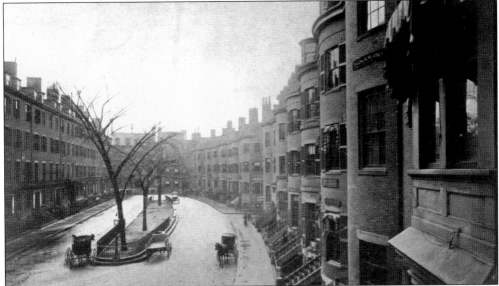

Pemberton Square, shown here in 1885, was a peaceful and elegant enclave on the eastern slope of Beacon Hill. The creation of visionary entrepreneur Patrick Tracey Jackson, it attracted the most wealthy and aristocratic Bostonians. At one time, almost half of New England's millionaires were residents of Pemberton Square. Later, the din of Scollay Square's increasing commercial activity and the influx of immigrants drove many Pemberton Square families farther up Beacon Hill to the newly constructed Back Bay. It needs to be noted that most boardinghouses of the era were respectable institutions. The mother of Jared Sparks, a future president of Harvard College, ran a boardinghouse on Ashburton Place, which rivaled many literary salons. (Courtesy of the Boston Athenaeum.)

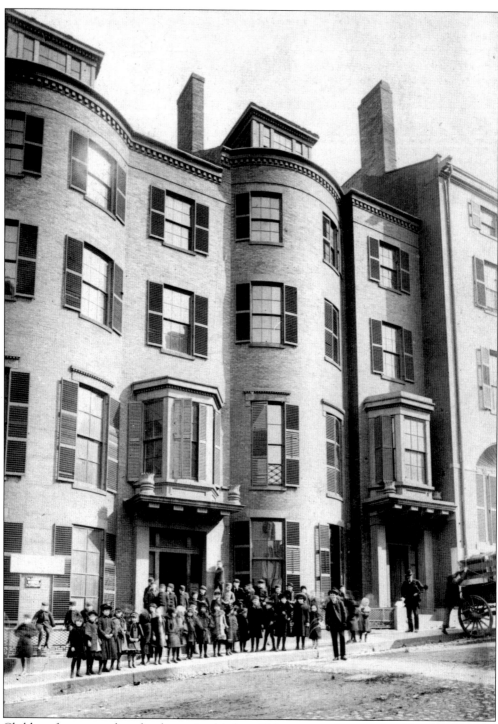

Children from a nearby school pose in this late-19th-century photograph of Somerset Street. Families with children, once common on upper Beacon Hill, diminished as apartments, businesses, and government buildings began to replace single-family residences at the turn of the century. (Courtesy of the Bostonian Society.)

The four-story Caleb Loring
House on Somerset Street,
viewed diagonally from
Ashburton Place, illustrates a
typical early-1800s brick dwelling
in this prosperous area. (Courtesy
of the Bostonian Society.)

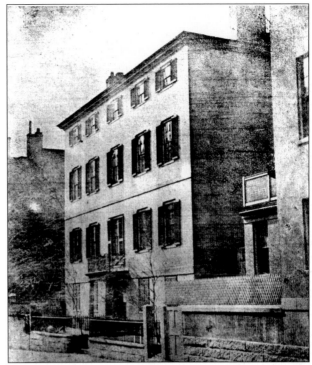

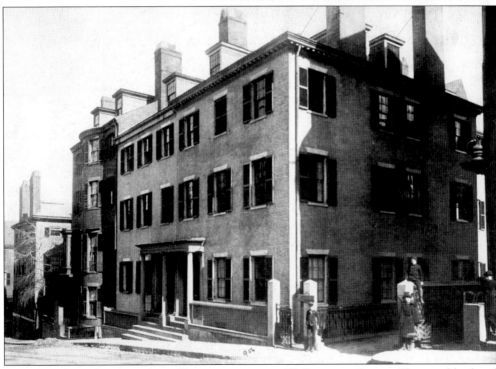

Daniel Webster lived in this affluent mansion at 37 Somerset Street. The neighborhood
children in the photograph are a reminder that this was once an area of affluent, single-family
homes. (Courtesy of the Bostonian Society.)

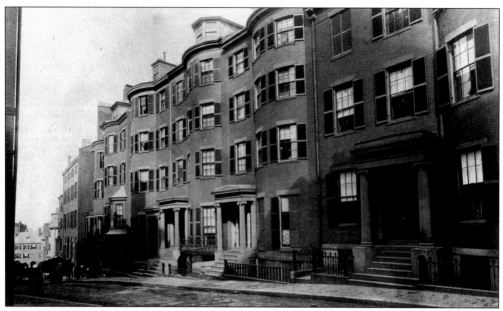

This early-1800s street scene shows Somerset Street as it travels down toward Howard Street. The brick bowfronts housed single homes with families and were influenced by nearby wealthy Pemberton Square. Rooming houses and boardinghouses later occupied this area. (Courtesy of the Bostonian Society.)

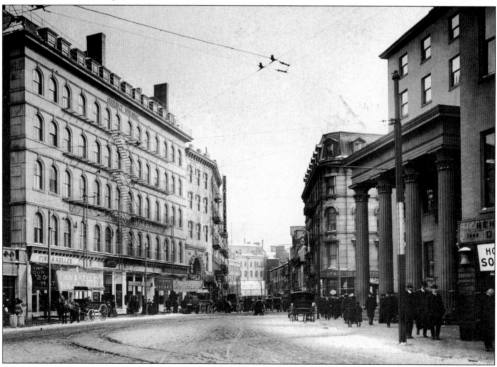

This 1880 photograph captures bustling Bowdoin Square, situated at the bottom of Bowdoin Street. The Greek pillars to the right mark the Revere House, a popular hotel of the period. (Courtesy of the Boston Public Library.)

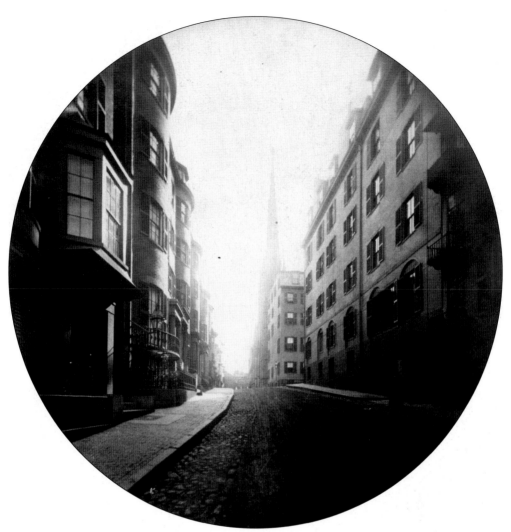

Somerset Street of the 1860s rises invitingly before the eye in this J.J. Hawes daguerreotype from Southworth and Hawes. The tall spire at the crest of the hill belongs to the First Baptist Church. (Courtesy of the Boston Public Library; photograph by J.J. Hawes.)

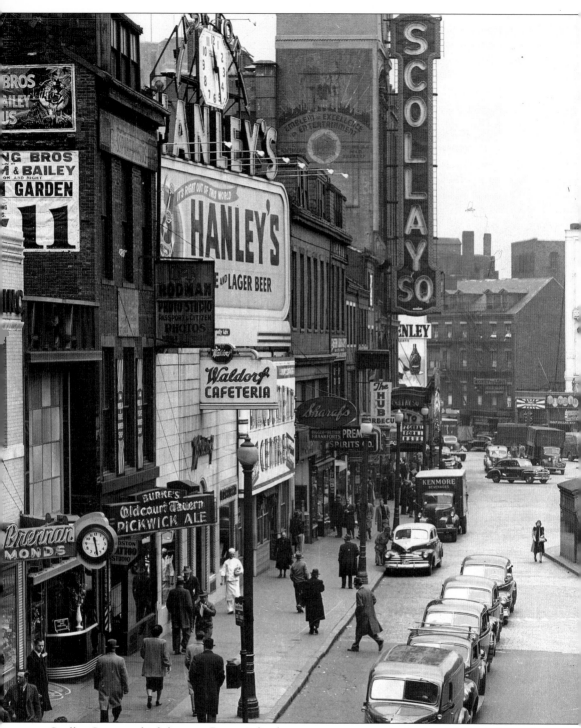

Scollay Square, which became Boston's lively amusement center in the late 1800s, is shown in this 1942 photograph. Theaters, bars, hotels, cafeterias, arcades, and nightclubs crowd Cambridge Street. Names like the Old Howard Theater, the Crawford House, and Joe and Nemo's hot dog stand were widely popular. Considered a blight on the city by many public

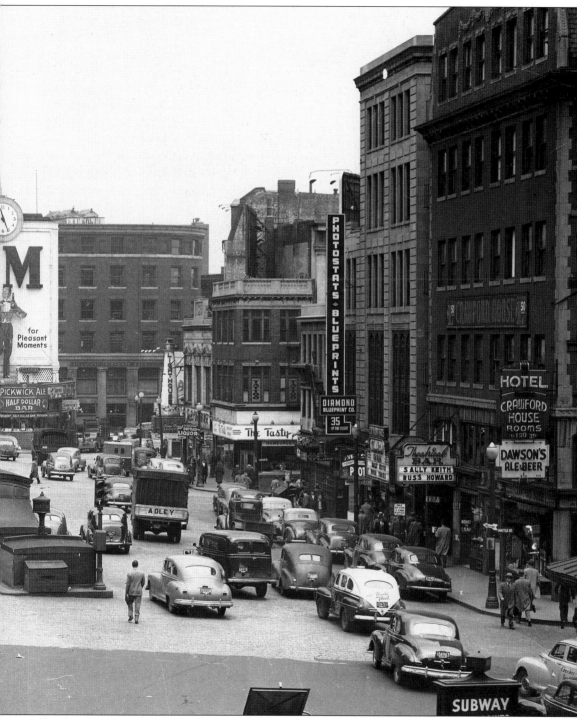

officials and community leaders, Scollay Square was razed beginning in 1961 to make way for the construction of the new Government Center. (Courtesy of the Boston Public Library; photograph by Leslie Jones.)

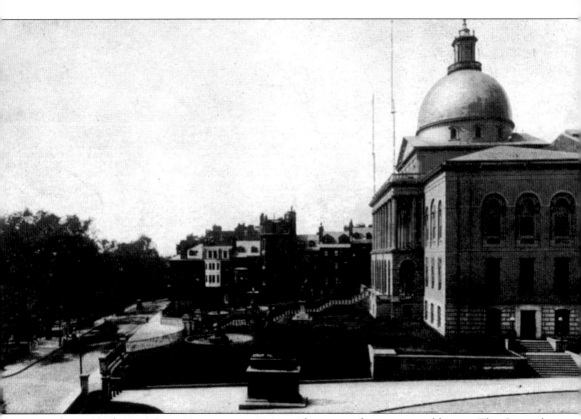

The Massachusetts State House is seen prior to the east and west wing additions. The General Hooker statue is in the foreground. (Courtesy of Dr. Michael C. Stone.)

Three
ARCHITECTURAL
NOTABLES

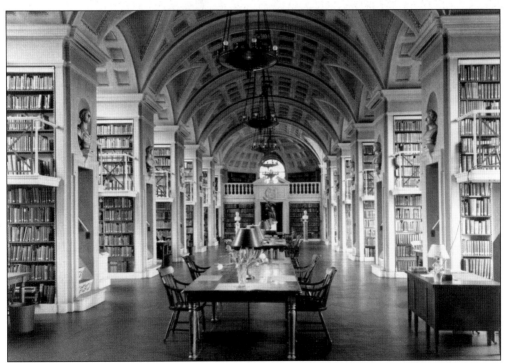

The Boston Athenaeum's fifth-floor reading room, a cathedral-like room added to the top of the Boston Athenaeum in 1913–1914 by architects Henry Forbes Bigelow and Philip Wadsworth, provides scholars and researchers an ideal environment for reading and study. A small adjoining terrace gives an unusual view of the Old Granary Burial Ground and surrounding rooftops. (Courtesy of the Boston Athenaeum.)

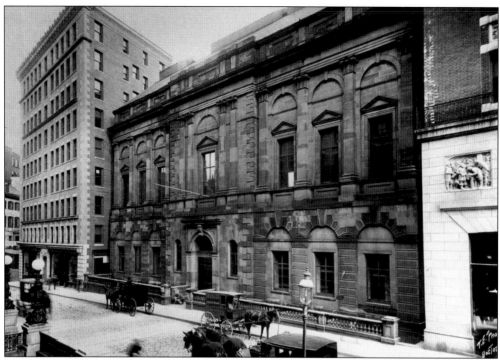

The Boston Athenaeum, located at 10½ Beacon Street and built in 1849, is an outstanding example of mid-19th-century Boston architecture. Shown here in a 1902 photograph, it houses a strong humanities collection, including books on art, history, and literature. Among its special collections are the private letters and books of George Washington and Gen. Henry Knox. It was made a historic landmark in 1966. Readers, scholars, and researchers, from Ralph Waldo Emerson to David McCullogh, have found a haven in this unique institution. (Courtesy of the Boston Athenaeum.)

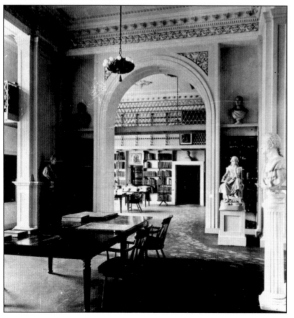

The Boston Athenaeum's second floor is an example of the building's newly expanded space, following its major 1913–1915 renovations. Deemed in 1911 by proprietor Charles Francis Adams "a pinewood firetrap," the building was completely fireproofed after the removal of its entire contents. The extensive remodeling and rebuilding created what the press called the "new Athenaeum." Refinement and the use of artwork, as shown here, pervade this venerable Beacon Street treasure. (Courtesy of the Boston Athenaeum.)

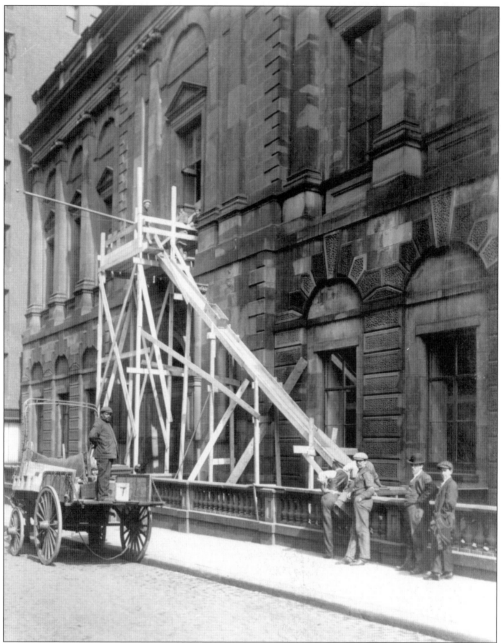

Workmen and passersby watch the removal of books from the Boston Athenaeum during its 1913–1915 renovation. A chute carried wooden boxes filled with books from the second floor to the street. The renovation included the addition of two stories. By the use of skillful changes and additions, the Boston Athenaeum has been able to stay at its 10^1/$_2$ Beacon Street address for more than 150 years. The first major renovation since 1915 began in 1999 and will provide access to the library's world-famous collection well into the 21st century. Perhaps the most important component of the current renovation is the addition of critical climate-control equipment, which will assist in the conservation of the unparalleled collection of books and works of art. (Courtesy of the Boston Athenaeum.)

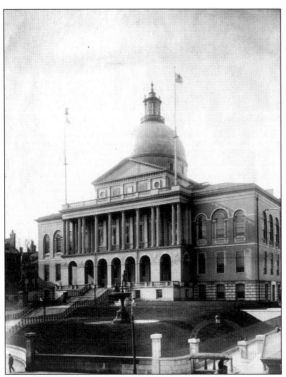

The design for the Massachusetts State House was conceived by Boston architect Charles Bulfinch on his return from a two-year tour of Europe in 1787. The resulting building shows English influence and Thomas Jefferson's tutelage in France. Placed at the summit of Beacon Hill in John Hancock's pasture, the statehouse quickly became a symbol of the new republic's rising influence. The front (south) facade shows a projecting portico with Corinthian columns supported on a lower arcade. The central dome, originally made of painted wood shingles, was replaced by Paul Revere with copper sheathing, which remained until the dome was later gilded. The pine cone on the top of the dome's lantern symbolizes the bountiful forests of Maine, once a part of Massachusetts. (Courtesy of the Boston Athenaeum.)

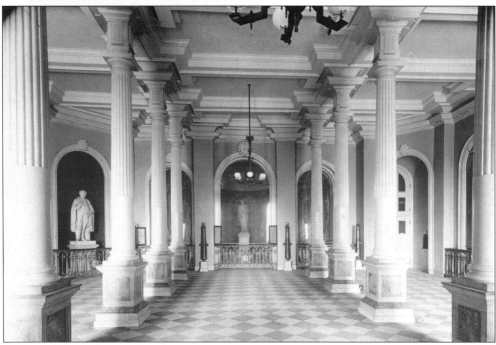

Here, the first-floor Doric Hall in the original Bulfinch portion of the statehouse under the dome appears as it was in 1897 before restoration began. Named for its Doric columns, it contains statues and busts of the country's and state's outstanding leaders. (Courtesy of the Boston Public Library.)

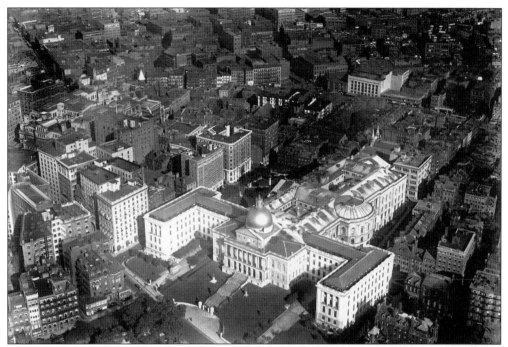

This splendid aerial view of the Massachusetts State House outlines the building's subsequent additions. The original Bulfinch portion shown in the front center was lengthened with a rear annex in 1889–1895 by Charles E. Brigham. (Courtesy of the Boston Public Library; photograph by Leslie Jones.)

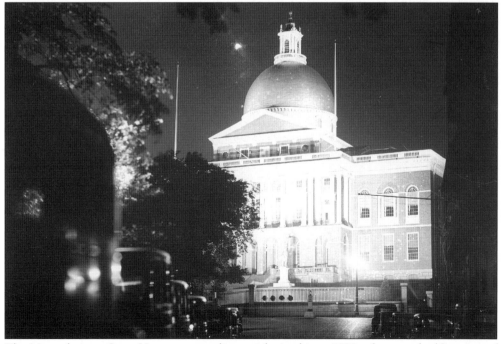

The Massachusetts State House appears lit at night in this c. 1930s photograph. (Courtesy of the Boston Public Library.)

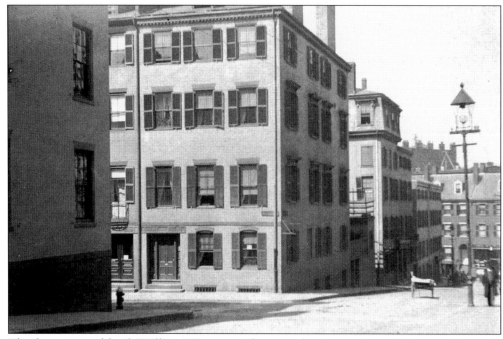

The four-story red-brick William Warren residence at the intersection of Somerset Street by Allston Street typifies the neighborhood's solid, affluent, mid-19th-century architecture. (Courtesy of the Boston Public Library.)

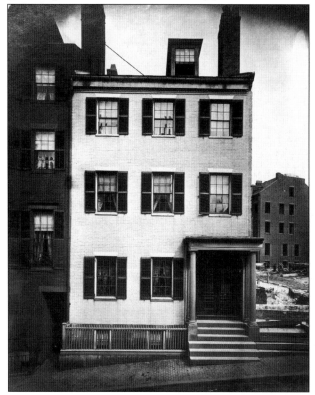

This plain, three-story brick residence at 39 Somerset Street c. 1880 shows a classic Greek Revival–style entrance. The front supports are simple modelings of Greek Doric-style columns. (Courtesy of the Society for the Preservation of New England Antiquities.)

The Hinckley House, located at 1 Somerset Street, appears here showing evidence of many additions. It was the home of the Old Congregational House *c.* 1890 and also the original Somerset Club. It is included here to show its interesting window arrangement. In older, substantial buildings, the ground-level floors and windows were small to shut out street noise and dirt, while the first floor or, *piano nobile*, was the principal, more formal floor with attendant tall windows. Each floor above the first showed smaller and smaller windows ending in attic or dormer windows. It was the invention of the elevator that reversed this size order, eventually putting the wealthy at the top of the building, since climbing stairs was no longer in question. In some cases, penthouses replaced the dormers and attic windows, so pleasant views could be enjoyed. (Courtesy of the Bostonian Society.)

Situated in Bowdoin Square, with Cambridge Street on the left and Green Street on the right, the Blake-Tuckerman houses formed a monumental presence near the convergence of Beacon Hill and Boston's West End. Designed by Charles Bulfinch, this large double house was completed in 1815 by Samuel Parkman for his two married daughters, Mrs. Edward Blake and Mrs. Edward Tuckerman. The Chelmsford granite structure defined the square's western edge for nearly 90 years. It was demolished in 1902. (Courtesy of the Boston Public Library.)

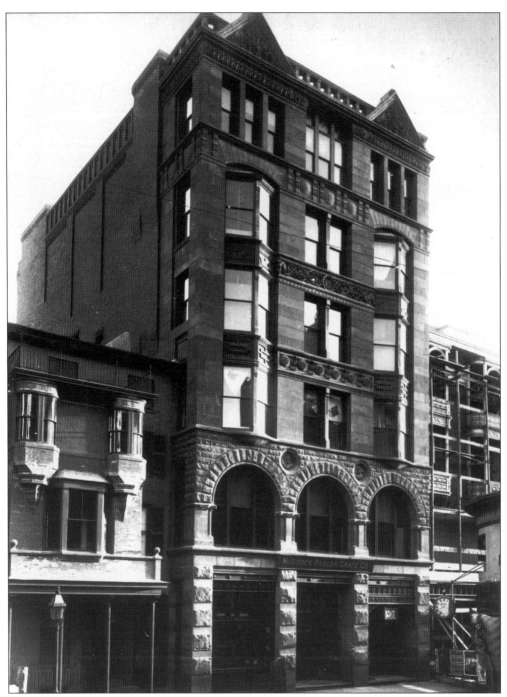

The Claflin building (center), at 18–20 Beacon Street, is strikingly handsome, with a Richardsonian Romanesque base topped by lighter, Queen Anne–influenced upper stories. Built in 1883–1884 and designed by architect William G. Preston, the building contrasts sharply with its much older neighbor, the 1808 Chester Harding House (left), at 16 Beacon Street. (Courtesy of the Society for the Preservation of New England Antiquities; photograph by Soule.)

The Chester Harding House, at 16 Beacon Street, a small, four-story brick Federal house built in 1808 by Thomas Fletcher, is the headquarters of the Boston Bar Association, the country's oldest legal organization. The artist Chester Harding lived here. The house's original owner was Dr. Henry C. Angell. The house's protruding oriel windows and other later alterations have been removed since this 1905 photograph was taken, resulting in a pleasing restoration of the original building. (Courtesy of the Society for the Preservation of New England Antiquities.)

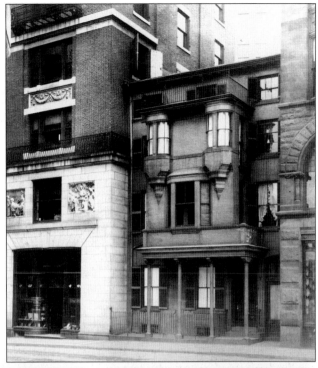

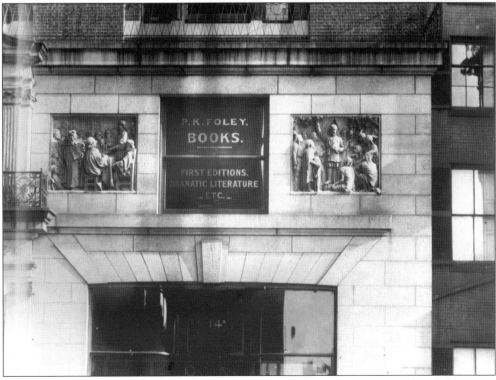

The Congregational House's lower Romanesque base is shown here in more detail. (Courtesy of the Society for the Preservation of New England Antiquities; photograph by Soule.)

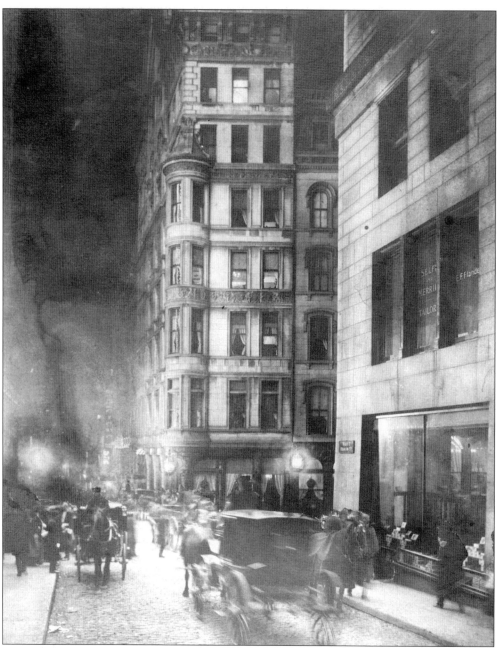

The Parker House at night evokes a romantic feeling in this *c.* 1902–1910 photograph taken at the corner of Tremont and Beacon Streets. One can almost hear the sound of the horse's hooves on the cobblestones. First opened by Harvey D. Parker in 1855, the Parker House was known as one of the first Boston hotels to introduce French cuisine. It hosted such outstanding figures as authors Charles Dickens and Willa Cather, as well as Isabella Stewart Gardener, Sarah Bernhardt, Elizabeth Cadey Stanton, and Joan Crawford. Called "the grande dame of hotels" and "the downtown hotel choice for historic minded Bostonians," the hotel's many additions also earned the hotel the name "the white French chateau." (Courtesy of the Boston Public Library.)

The exterior of the Women's Business Clubhouse, at 144 Bowdoin Street, is shown here at its opening in October 1912. A French mansard roof with three dormers tops this attractive building, which was soon after replaced by a rooming house and subsequently converted to apartments. The Fill-A-Buster restaurant is currently at the ground level of the apartment building. Lack of city zoning ordinances produced similar, rapid architectural changes in the area. To the upper left of the clubhouse is a portion of the Church of the New Jerusalem. (Courtesy of the Boston Public Library.)

The graceful Amory-Tichnor mansion occupies 9 Park Street at the corner of Beacon and Park Streets on the site of a former almshouse. Charles Bulfinch built it for a wealthy merchant, Thomas Amory, in 1803–1804. However, business failures resulting from the loss of several of his ships at sea led to bankruptcy for Amory, hence the name "Amory's Folly." The mansion was then turned into a boardinghouse for politicians and, in 1806, was divided in half. George Tichnor, a Harvard professor, occupied the Beacon Street side. (Courtesy of the Boston Public Library.)

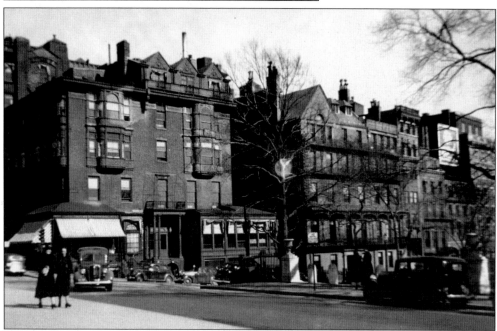

Taken 55 years later, this 1938 photograph of Bulfinch's Amory-Tichnor mansion shows evidence of neglect and new architectural additions. Protruding oriel windows, roof dormers, and shop awnings have all become a part of this elegant former home. An antiques store and the café Curious Liquids were once tenants of the lower portions of the house. The house is now being converted to condominiums, and a new restaurant occupies 9 Park Street's ground level. (Courtesy of the Boston Public Library; photograph by Paul Swanson.)

Architect George A. Clough's grand Suffolk County Courthouse (completed in 1896) is today the lone historic holdout in an enclave dominated by urban renewal–era architecture of grand proportions. At the time of its construction, however, the massive French Second Empire building was the hulking newcomer, displacing the western half of the tranquil 1830s residential crescent known as Pemberton Square and forever changing the architectural scale of the area. (Courtesy of the Boston Public Library.)

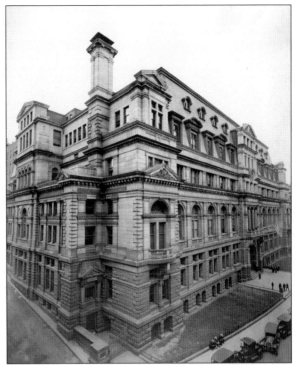

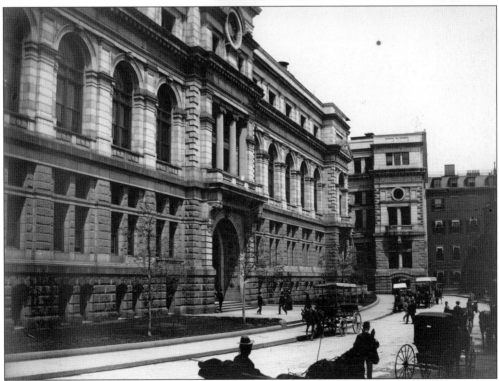

This photograph of the Suffolk County Courthouse is from the Leslie Jones collection. (Courtesy of the Boston Public Library.)

This 1950s street scene of upper Bowdoin Street at the corner of Beacon Street affords the viewer a striking cross section of the neighborhood's changing tastes. Here, the western addition of the Hotel Bellevue displays fanciful Beaux Arts French-influenced mascarons, or carved stone faces, on its exterior, along with ornate balconies. A magnet for the statehouse

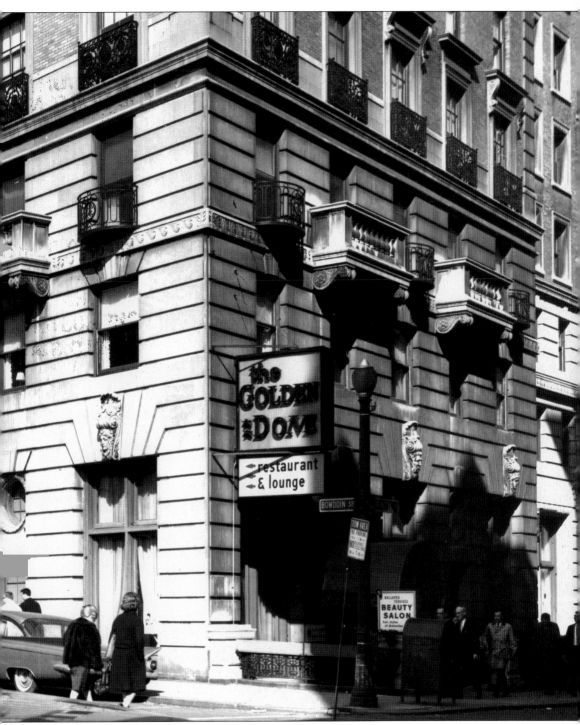

politicians, the Golden Dome pub, located on the Beacon Street side of the hotel and also called the State House Annex, replaced the Bellevue Pub, marked now only by a rare theater marquee, or entrance covering. (Courtesy of the Bostonian Society.)

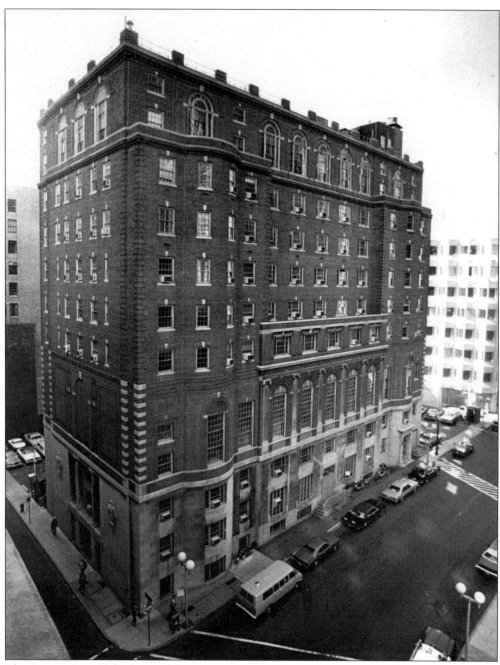

The Boston City Club, designed by architects Newhall and Blevens, was built in 1913. Formed for the executives and workers of Boston's growing business community, it housed two restaurants, a movie theater, and several guest rooms. It was located on Somerset Street with a side entrance on Ashburton Place. An older area resident remembers being taken to the Boston City Club for Saturday movies for children by his father. (Courtesy of the Suffolk University Archives.)

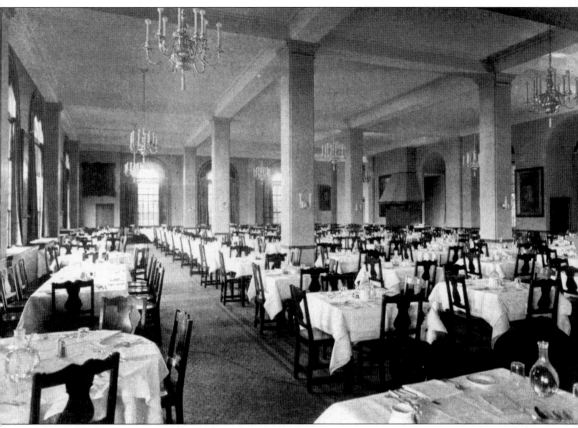

The Boston City Club main dining room is shown in 1915. (Courtesy of the Society for the Preservation of New England Antiquities.)

The mixed usage of business, apartments, and public buildings shown in this photograph is typical of the late-1800s era. (Courtesy of the Bostonian Society.)

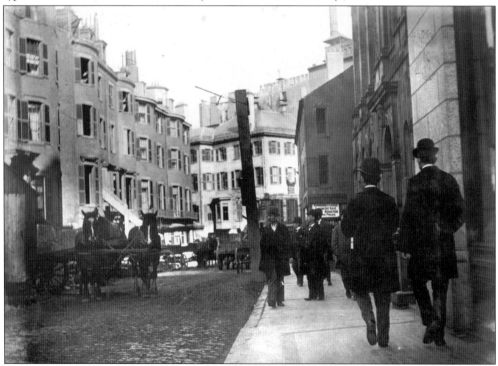

Men in bowler hats walk down Beacon Street in this 1899 photograph. The Hinckley House is at the end of this view. The large vertical pole in the center is part of a hoist used to put the Congregational House's cornerstone in place. The brick bowfront houses on the left side of Beacon Street are typical of upper Beacon Hill architecture of the period. (Courtesy of the Bostonian Society.)

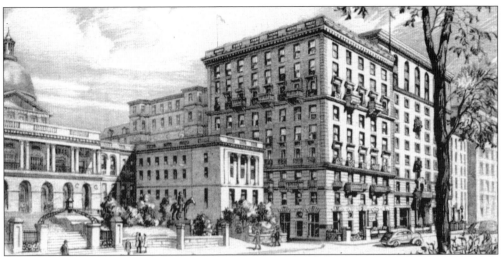

This 1940s postcard of the Hotel Bellevue's Peabody and Stearns structure (built in 1899) and the later Putnam and Cox addition on Bowdoin Street gives the viewer a glimpse of this Classical Revival and Beaux Arts building. The site of many innovations, it boasted Boston's first hotel passenger elevator, first café, and first roof garden. A 24-hour telephone system linked guests with long-distance destinations, and the hotel's cuisine received high compliments from Boston newspapers. The closets were even "lit by electricity," commented a writer of the era. To the hotel's left is the Massachusetts State House with its east wing addition. (Courtesy of Dr. Michael C. Stone.)

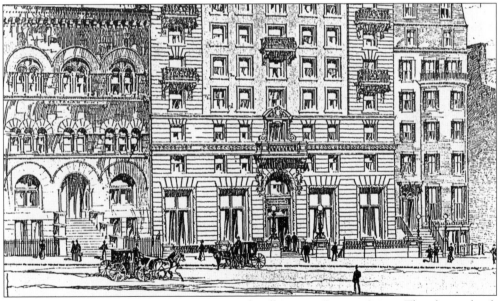

An architect's rendering details the new Hotel Bellevue on Beacon Street. The elegant brick and limestone Beaux Arts and Classical Revival–style hotel's luxuriously appointed rooms and modern conveniences—a bathroom with every room—attracted many American and European notables. In the next century, the Bellevue Pub, the hotel's famous men's bar, earned the *Boston Globe*'s praise as "a hangout for some of the state's most colorful figures." The building was converted to condominiums in 1983. The arched entrance to the left marks the Romanesque American Unitarian Association. (Courtesy of the *Boston Courier*.)

A period *Boston Globe* advertisement extols the Hotel Bellvue's many exciting new features. The hotel's high elevation on top of Beacon Hill made it appealing to health-conscious guests who were anxious to avoid the city's "bad air." (Courtesy of the *Boston Globe*.)

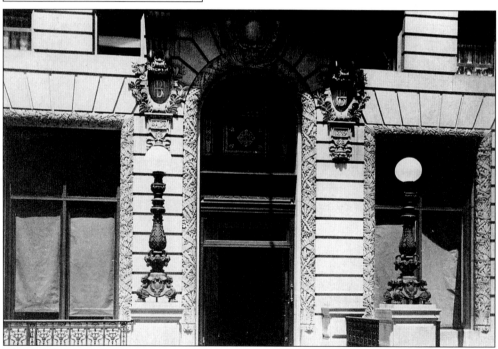

These elaborate stone carvings mark the entrance to the Hotel Bellevue (at 21 Beacon Street), designed by architects Peabody and Stearns. The French influence of Peabody, a student at the Paris Ecole des Beaux Arts, is shown here in the Beaux Arts usage of scrolls, shells, and acanthus leaves. The hotel's facade remains unchanged today. (Courtesy of the Boston Architectural Center.)

Four
ENTERTAINMENT

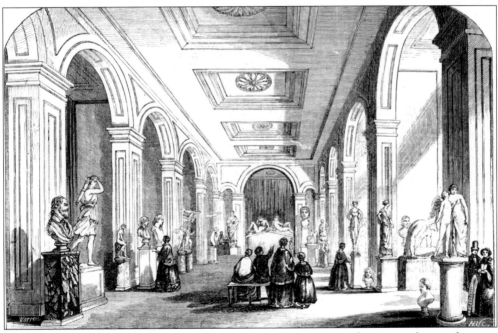

The Statuary Room at the Boston Athenaeum was an attraction for its members and guests. The neighborhood benefited through the century from the generous calendar of concerts, lectures, and art shows held at the Boston Athenaeum. Of course, there were also the hours of enjoyment and entertainment gained from reading the athenaeum's books. (Courtesy of the Boston Athenaeum.)

This c. 1870 chromolithograph advertisement shows the four-story Boston Museum, a popular theater built in 1846 on Tremont Street. The name of the theater speaks of Boston's lingering Puritan distrust for popular entertainment. The museum part of the building was of little interest; it served only to reassure the public of the theater's cultural responsibility. Prices per seat ranged from 35¢ to $1. (Courtesy of the Boston Athenaeum.)

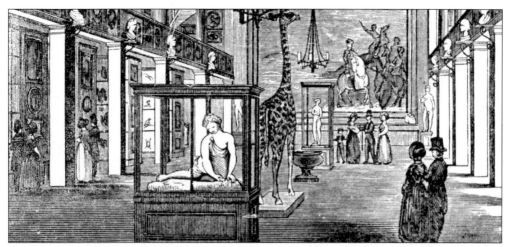

One of the exhibit halls at the Boston Museum is illustrated here. The sparse collection of statues, stuffed animals, and assorted artifacts satisfied the Puritan need for uplifting education. Theatergoers could then enjoy the theatrical performances. (Courtesy of the Boston Athenaeum.)

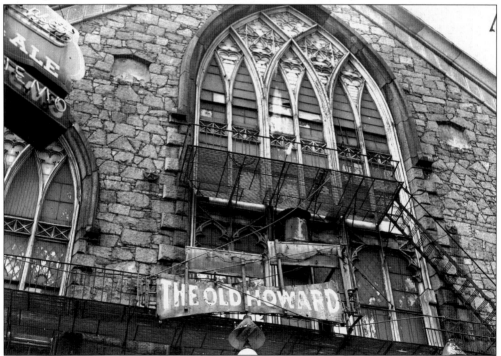

Famous for many reasons, the Old Howard Theater in Cambridge Street's Scollay Square began as a temple for a sect believing the world would come to an end in April 1844. After a fire, the temple-theater was rebuilt in granite, as shown in the photograph. The Howard temple next became a Shakespearean theater when the temple sect accepted that the world had not come to an end. Having sold all their possessions to be ready for heaven, they tried to recoup their losses by selling their temple as a classical theater. Among the stars on stage were the famous Sarah Bernhardt and the infamous John Wilkes Booth, who played Hamlet at the Howard. The theater seated 1,500 people, and prices ranged from 35¢ to $1. (Courtesy of the Boston Public Library; photograph by Leslie Jones.)

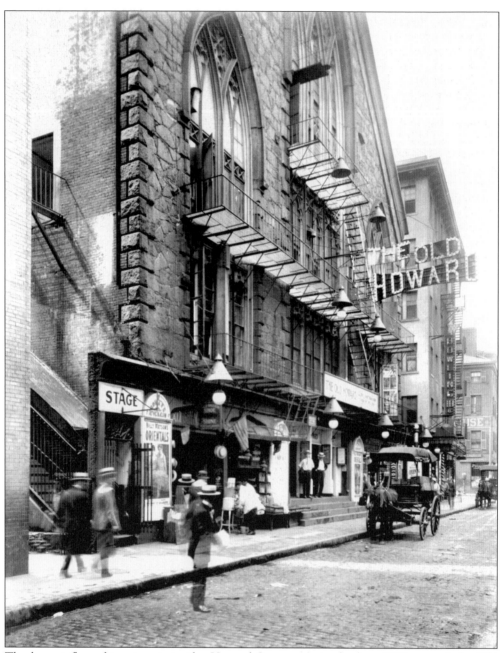

The huge influx of immigrants to the Howard Street area in the late 1800s caused the Old Howard Theater to again undergo abrupt change. Transitions from vaudeville to minstrel shows and finally burlesque met the needs of these immigrants for popular and inexpensive entertainment in the neighborhood. (Courtesy of the Boston Athenaeum.)

In the 1940s, Howard Street and Scollay Square began to deteriorate as tattoo parlors, numerous bars, shooting galleries, and joke shops moved into the area. In an effort to clean up Scollay Square, Boston city planners decided to locate the newly planned Government Center on this site. A 1961 fire of unknown origin helped to demolish the 115-year-old Howard Theater just as it was cited for destruction as part of Boston's urban renewal. Here, entertainer Ann Corio looks sadly at her playbill as demolition crews work in the background. (Courtesy of the Boston Public Library; photograph by Arnold Grant, published in the *Boston Traveler* on July 5, 1961.)

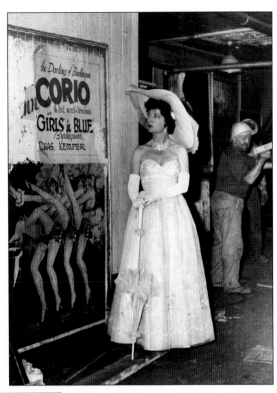

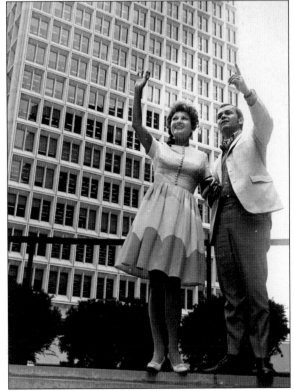

In this 1968 photograph, entertainer Ann Corio plays a sentimental visit to the area formerly occupied by the Old Howard, now the site of the Government Center. She is shown here in front of the Saltonstall building with Fran Connelly, manager of Framingham's Carousel Theater. (Courtesy of the Boston Public Library.)

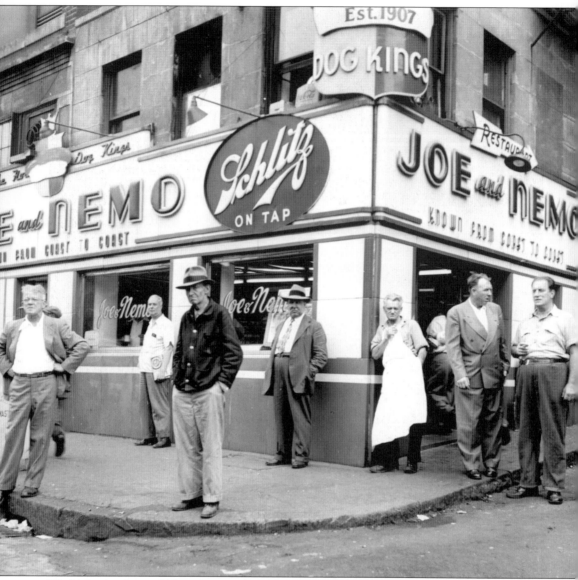

World-famous Joe and Nemo's, a small Scollay Square restaurant and hot dog stand, played a large part in the life of the Old Howard. It began in 1909 with Joe Merlino and Anthony "Nemo" Caloggero and became a surprising success during the Great Depression when they sold hot dogs for a nickel. Its location near the Old Howard brought the theater crowd in large numbers. Into the 1950s, performers such as George Burns, Gracie Allen, the Marx Brothers, Fred Allen, Fanny Brice, and Ann Corio joined soldiers, sailors, Harvard faculty, politicians, and visiting dignitaries at Joe and Nemo's 24-hour hot dog stand. This 1961 photograph captures the life of a Boston legend. (Courtesy of the Boston Public Library.)

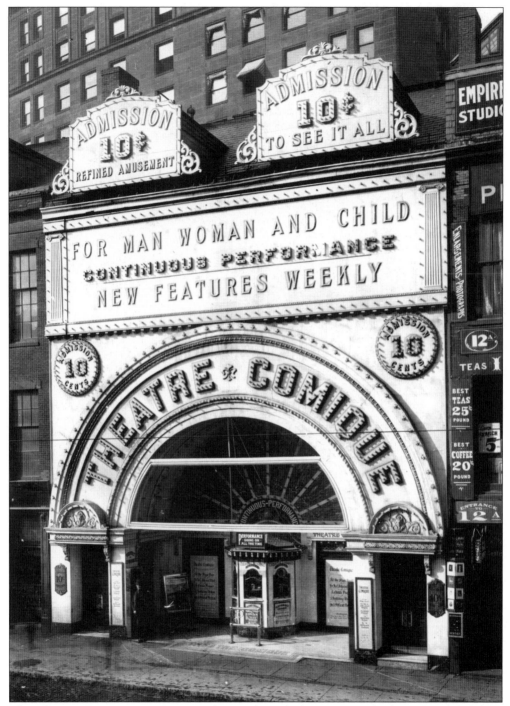

The Theatre Comique was Boston's first exclusively motion picture theater. It opened on September 3, 1906, on Tremont Row, which ran from Pemberton Square to Howard Street. It was open from 9:00 a.m. to 11:30 p.m. and showed short films initially, but later, longer movies were featured. Its 10¢ admission fee and promise of refined amusement made it a popular entertainment destination. (Courtesy of the Bostonian Society.)

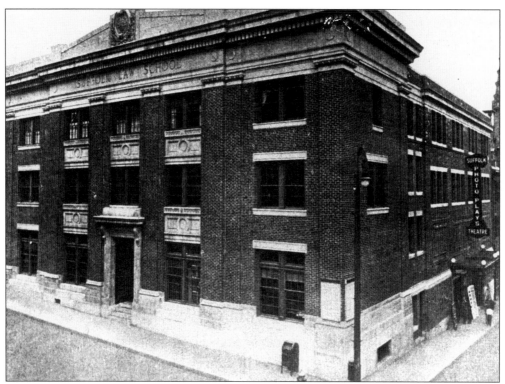

Suffolk Photoplays Theater was the creation of founder and president of Suffolk Law School, Gleason Archer. It was located on Temple Street in the original 1920s law school Derne Street building. Archer's plan was that the proceeds from the theater would finance the school's operation. Although his financial idea failed, Suffolk University now uses the auditorium as the C. Walsh Theater for theater productions, lectures, and university events. (Courtesy of the Suffolk University Archives.)

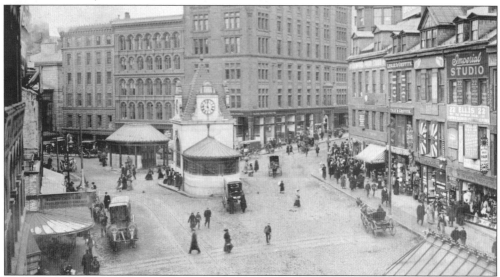

This 1908 photograph shows bustling Scollay Square, which was becoming a center for entertainment. (Courtesy of the Boston Public Library.)

Five

POLITICS AND GOVERNMENT

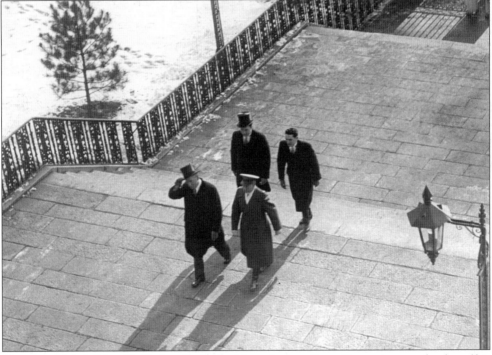

Governor-elect Michael J. Curley climbs the Massachusetts State House steps on the day of his inauguration ceremony on January 3, 1935. After three terms as the city's popular mayor, he became the first Democratic mayor of Boston to be elected governor of Massachusetts. His reputation as the man who "built Boston" and his fervent embrace of Roosevelt's New Deal enabled him to beat his opponent, Republican Gaspar G. Bacon, by a sizable margin. (Courtesy of the Boston Public Library.)

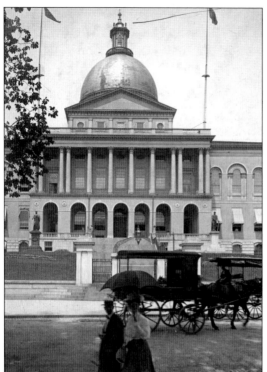

Celebrated as one of the finest public buildings in the country for decades after its construction, the Charles Bulfinch-designed Massachusetts State House is synonymous with upper Beacon Hill in the minds of many Bostonians. This c. 1900 photograph shows the south facade of the building without the granite-and-marble-clad east and west wings that were added between 1914 and 1917. The building has retained its functional role as the center of political life in the Commonwealth for more than 200 years. (Courtesy of the Boston Public Library.)

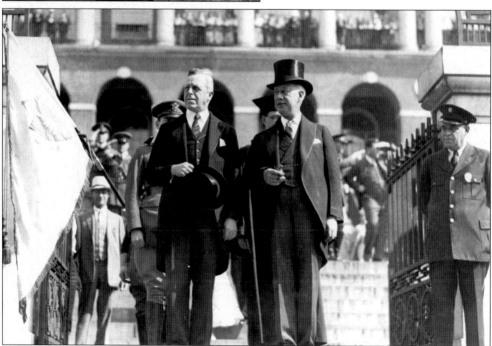

The upper Beacon Hill neighborhood has always been the site of celebrity. Gov. Joseph B. Ely (left) and New York's beloved Al Smith (right) walk down the steps of the Massachusetts State House on their way to receive honorary degrees from Harvard University. (Courtesy of the Boston Public Library.)

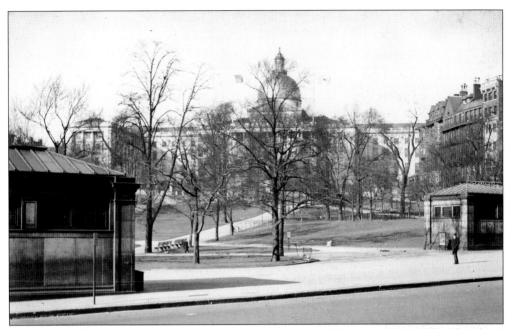

This view of the Massachusetts State House was taken from the steps of St. Paul's Church on Tremont Street. (Courtesy of the Boston Public Library.)

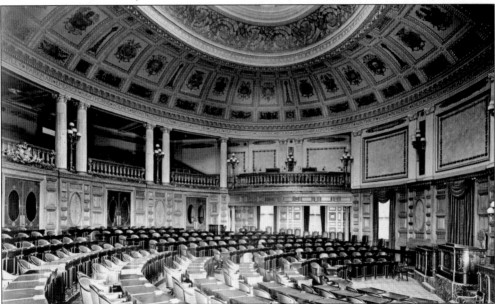

The House of Representatives is part of the governing body of the Massachusetts state government housed in the Massachusetts State House. The frame of the state's government is established in its constitution and gives responsibilities to each of the three branches. The legislature, or General Court, consists of two bodies, the Senate and the House of Representatives. The governor acts as the supreme executive in the executive branch, and judicial officers hold the judicial power. Changes have been made in the government structure, but its base remains the same, dating back to early days when freemen used Native American corn for a yes vote and a bean for a blank vote. (Courtesy of the Boston Public Library.)

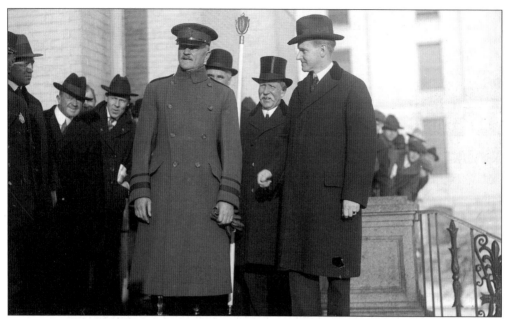

Gen. "Black Jack" Pershing (left) and Gov. Calvin Coolidge appear in this 1920 photograph in front of the Massachusetts State House. Pershing commanded the American Expeditionary Forces in Europe during World War I.

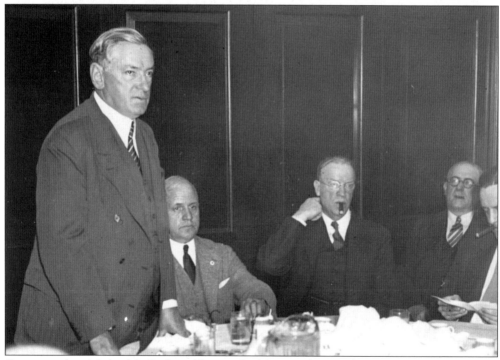

Governor-elect Michael J. Curley addresses the Mayors of Massachusetts at a special meeting at the Parker House in November 1934. He outlined his plan for extensive housing in the state. To the right of Curley are Mayor Andrew A. Casassa of Revere, president of the Mayor's Club of Massachusetts, and Mayor Mansfield. (Courtesy of the Boston Public Library.)

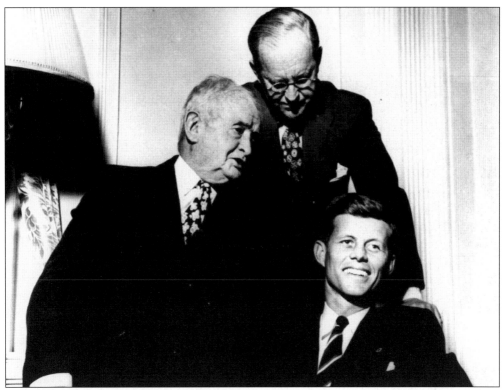

Look magazine in 1946 featured John F. Kennedy with his father, Joseph P. Kennedy, and his beloved grandfather, John F. Fitzgerald, former mayor of Boston. Fitzgerald died while a resident of the Hotel Bellevue at 21 Beacon Street. President Kennedy and later Senator Kennedy also lived at 21 Beacon and later at 122 Bowdoin Street. (Courtesy of the Kennedy Library.)

John F. "Honey Fitz" Fitzgerald was an active and colorful local and national political figure whose name is synonymous with the growing influence of Boston's newly arrived Irish immigrants. He was elected to Congress in 1894 and was the only Democrat from New England and the only Irish Catholic in Congress. His stand against Sen. Henry Cabot Lodge's Immigration Restriction Bill aided in its defeat. Fitzgerald next served as mayor of Boston for two terms in 1906–1907 and 1910–1913, with the slogan "Bigger, Better, Busier Boston." The photograph shows Fitzgerald in his suite at the Hotel Bellevue, where he and his wife lived after they left their home in Dorchester. When young John Kennedy came home from World War II and decided to run for Congress, he accepted his grandfather's invitation to move into the Bellevue and, in fact, lived next to him on the third floor. Time spent with "Honey Fitz" was a political asset for John F. Kennedy, and there was no better place to learn about Boston politics than the Bellevue's Golden Dome pub. (Courtesy of the Kennedy Library; photograph from *Look* magazine.)

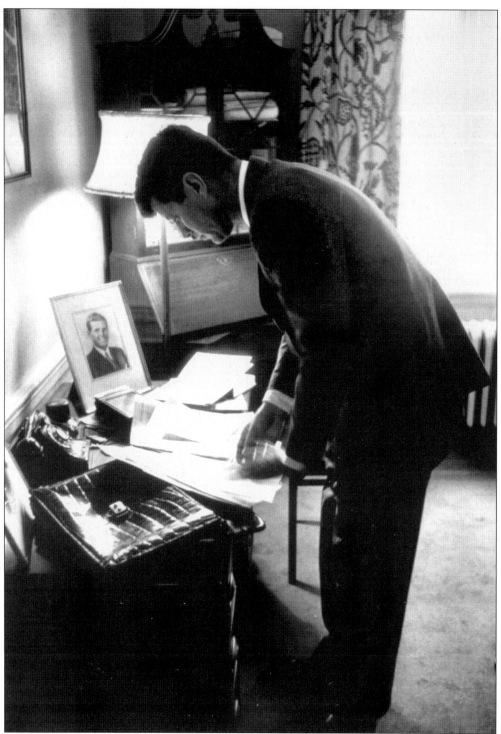

John F. Kennedy is seen at his desk in his apartment at 122 Bowdoin Street in this 1957 photograph. On the desk is a picture of his deceased brother, Joseph Kennedy. (Courtesy of the Kennedy Library; photograph from *Look* magazine.)

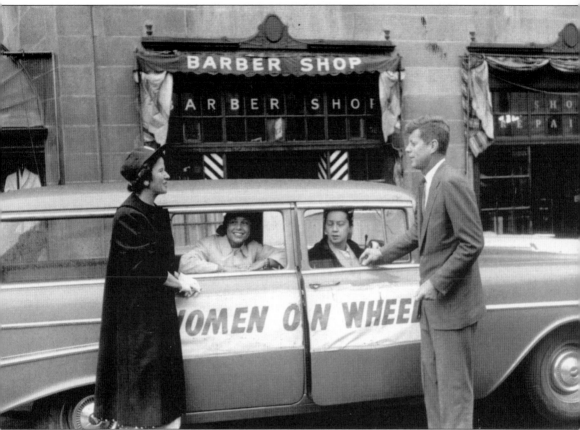

John F. Kennedy is shown here in front of his apartment at 122 Bowdoin Street. With him are members of Women on Wheels, an auxiliary of the Massachusetts State Democratic Committee, which was active in his 1958 senatorial campaign. Participants in the organization included Kennedy's mother, Rose, and his sisters, who gave their famous tea parties to mobilize women voters across the state. The barbershop and shoe-repair shop in the background are still in operation for the convenience of the employees and elected officials at the Massachusetts State House across the street. (Courtesy of the Kennedy Library; photograph from *Look* magazine.)

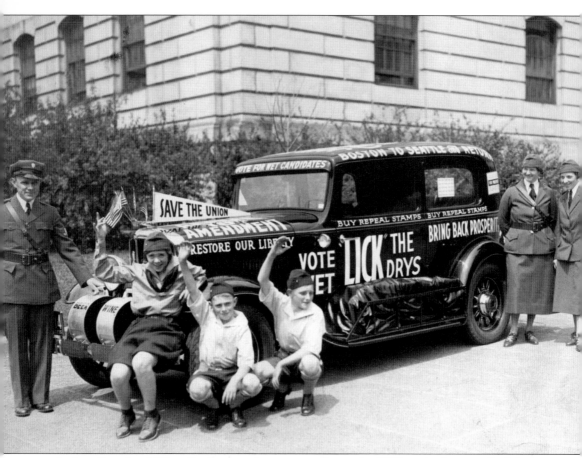

Arthur Stanek of West Roxbury and party are shown in 1932 with the anti-Prohibition Crusader's Coast-to-Coast automobile at the Massachusetts State House. Governor Ely and Mayor Curley were present to lend support to the departing campaigners. (Courtesy of the Boston Public Library; photograph from the *Boston Herald Traveler*.)

Six

WOMEN IN VIEW

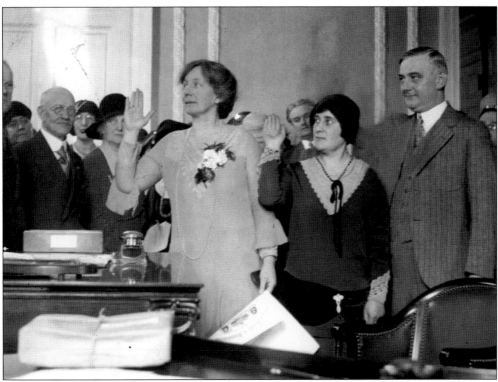

The first two women justices appointed in Massachusetts history are seen in this 1930 photograph as they take the oath of office before Gov. Frank G. Allen. From left to right are Emma Fall Schofield, Sadie Lipner Shulman, and an unidentified man. (Courtesy of the Boston Public Library.)

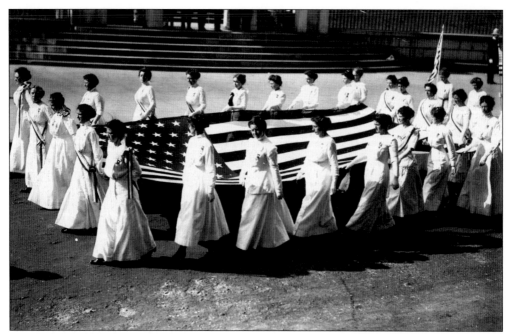

Women carry the flag on Flag Day, June 16, 1913, in front of the Massachusetts State House. The seeming innocence of the times was broken just a year later with the outbreak of World War I in June 1914. (Courtesy of the Boston Public Library.)

Here are Mrs. Eben S. Draper, wife of former governor Eben S. Draper, and daughter Dorothy. Draper served two terms of office from 1909 until 1911. (Courtesy of the Boston Public Library.)

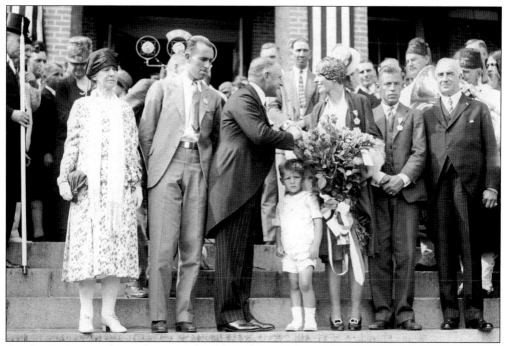

Amelia Earhart is shown here on the Massachusetts State House steps, receiving flowers in honor of her recent triumph. She was the first woman to cross the Atlantic Ocean in an airplane and, on June 17, 1928, went from Newfoundland, Canada, to Wales in the British Isles.

Gov. Frank G. Allen greets members of the annual convention of the Kappa Beta Phi sorority in this 1929 photograph. From left to right are Emma Tousant of the State Industrial Accident Board; Governor Allen; Estelle Thorpe Russell, president of the sorority; Marie Saunders of Washington; and Katherine Pike, vice president of the organization. The early 1900s saw a dramatic rise in the creation of clubs and social groups for women. (Courtesy of the Boston Public Library; photograph from the *Boston Herald*.)

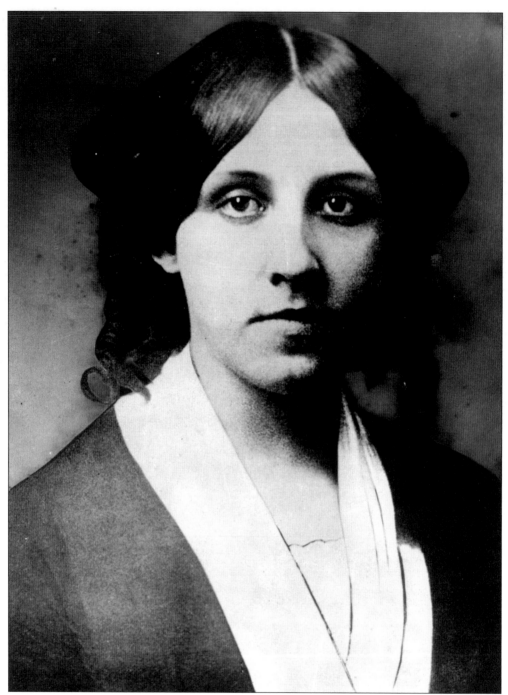

Louisa May Alcott, noted author of *Little Women*, wrote *Eight Cousins*, *Jack and Jill*, and *A Modern Masterpiece* while in residence at the Hotel Bellevue at 17 Beacon Street. She left the winter isolation of nearby Concord, preferring to spend four winters at the Bellevue, where she lived under the hotel's mansard roof in her sky parlor. She delighted in the stimulation of the hotel's literary salon in the Bellevue's cafe. Henry Wadsworth Longfellow and Ralph Waldo Emerson were some of its members. (Courtesy of the Boston Public Library and the Victorian Society.)

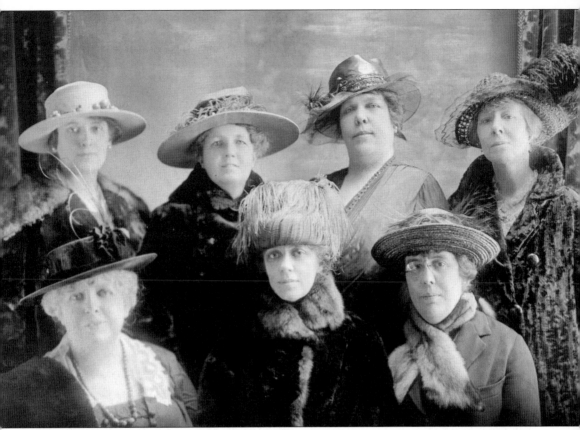

The Talent Committee for the Salvation Army Pageants Committee is shown in this 1920 photograph. From left to right are the following: (front row) Pauline Hammond Clarke, Marie Dewing Ferelton, and Jeanette Bell Ellis; (back row) Alice L.B. Gurlach, Minda del Castillo, Bertha Wesselhoeft Swift, and Eliot Long. The strong American movement of women volunteers engaged in charitable works began to flourish in the early 1900s in the Beacon Hill area. The role of women volunteers in the Civil War had paved the way for this trend. (Courtesy of the Boston Public Library.)

The Storrow room was established in memory of Mrs. James J. Storrow, philanthropist and first president of the Women's City Club. The Women's City Club, now at 40 Beacon Street, had its early beginnings in a brick bowfront on the site now occupied by the Lawyer's Building. (Courtesy of the Boston Public Library; photograph from the *Boston Herald*.)

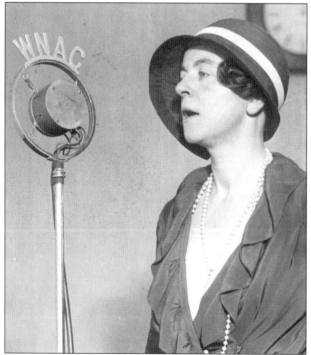

Here, in 1930, Mrs. Eben S. Draper, wife of Republican candidate for the Senate Eben S. Draper (son of former governor Eben S. Draper), makes her first radio message on his behalf. Eben S. Draper held the office of U.S. senator from 1923 to 1926. (Courtesy of the Boston Public Library; photograph from the *Boston Herald*.)

Seven
URBAN PROGRESS

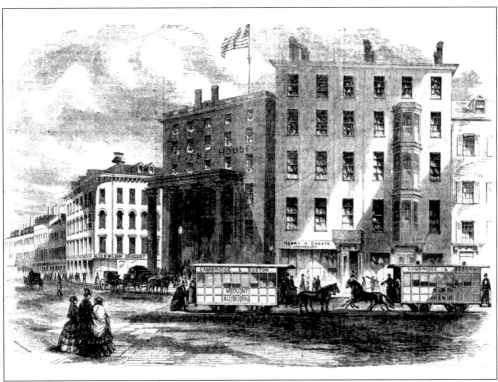

Horses with the new Boston and Cambridge horse railroad cars of the Union Railroad Company step smartly along Cambridge Street. Shown at the corner of Court and Bulfinch Streets in this 1856 wood engraving are Bowdoin Square's Revere House hotel, the apothecary shop of Henry A. Choate, and the shop of druggist Alex B. Wilbur. (Courtesy of the Boston Athenaeum; wood engraving from *Ballou's Pictorial Drawing Room Companion*, 1856.)

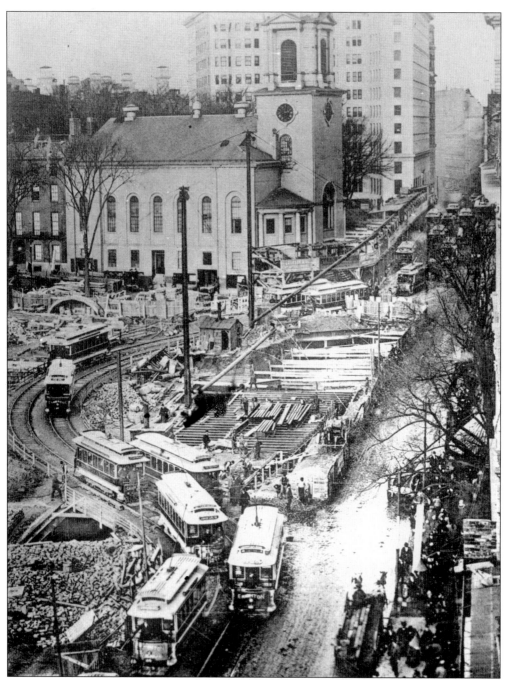

This 1895 photograph depicts trolleys being routed around the Park Street Station construction site. Increasingly unmanageable traffic conditions on Tremont Street necessitated action. The city's citizens voted to dig underground instead of building an unsightly elevated system. When the subway opened on September 1, 1897, the nation's first underground transit system was an overwhelming success. It not only ended congestion on the streets but also provided prompt transit, offered shelter from the elements, and paid rent to the city. (Courtesy of the Boston Public Library.)

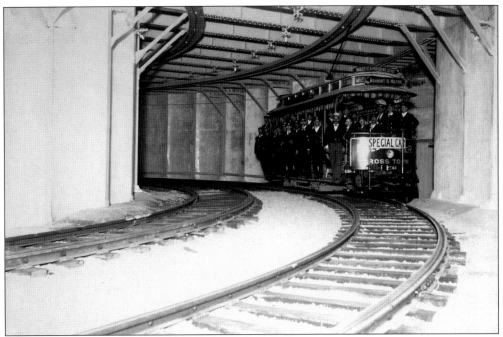

A subway car making a trial run from Park Street Station emerges here from the subway's underground tunnel on the day of the system's inauguration in 1897. (Courtesy of the Boston Public Library.)

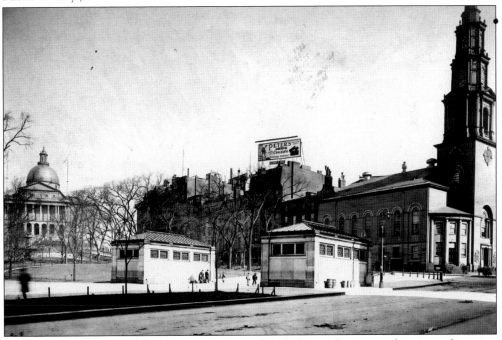

The twin entrances to the Boston underground Park Street Station and a strangely empty Tremont Street are visible in this 1910 photograph. In the background are the Park Street Church and the Massachusetts State House. Notice the prominent Peter's Chocolate sign, which would shock today's city planners. (Courtesy of the Boston Public Library.)

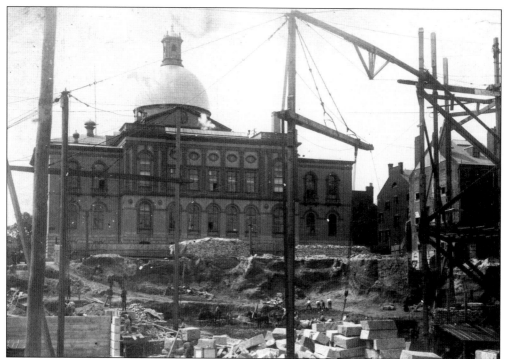

Upper Beacon Hill's constant flow of construction and demolition can be seen in this 1889 photograph. Amidst the rubble of the old Beacon Hill reservoir previously at this site behind the Massachusetts State House, construction work is proceeding for the laying of the foundation for the statehouse extension. Designed by architect Charles E. Brigham, the extension was completed between 1914 and 1917. (Courtesy of the Boston Public Library.)

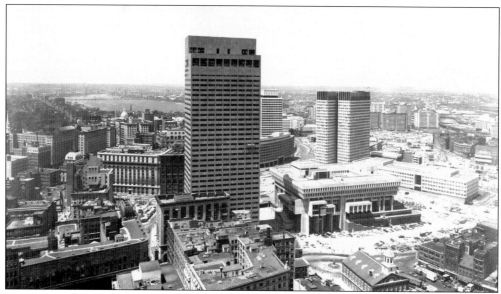

The Boston City Hall, shown to the right of the high-rise building, was built from 1961 to 1968. It was part of the Government Center project, which ushered in the "New Boston." Faneuil Hall can be seen in the right foreground.

The Church of the Disciples, a forgotten brick chapel, was located at the end of Freeman Place, an alley off Beacon Street opposite the Boston Athenaeum. Built in 1848 inside a block, a custom since Colonial days, it played an important role in Beacon Hill history. Its minister, James Freeman Clarke, was a liberal Unitarian who was an active abolitionist and who also advocated women's suffrage. He was a member of the Transcendentalist movement and met regularly with such members as Bronson Alcott, Margaret Fuller, Ralph Waldo Emerson, Louisa May Alcott, and Nathaniel Hawthorne. After the Unitarians left, the chapel became the site of Boston's first French-speaking Roman Catholic church. Known as Notre Dame des Victoires, the parish was led by Fr. Leon Bouland, a Lyon-trained priest whose charismatic and polished manner drew crowds from Beacon Hill to the small chapel— Protestant and Catholic alike. The church group later outgrew the building and moved to Isabella Street in Boston. (Courtesy of the Society for the Preservation of New England Antiquities.)

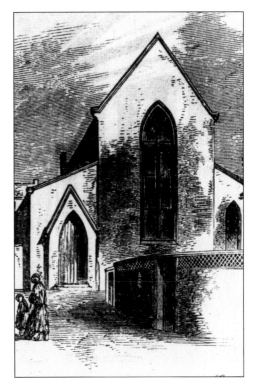

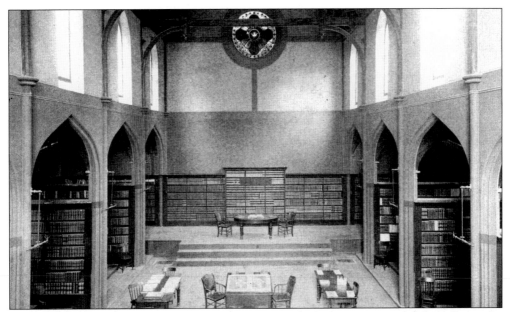

In this late-19th-century photograph, the Boston Book Company succeeds Notre Dame des Victoires, a small chapel on Freeman Place, opposite the Boston Athenaeum. The book company's choice to locate in a church is an example of early urban repurposing. (Courtesy of the Bostonian Society.)

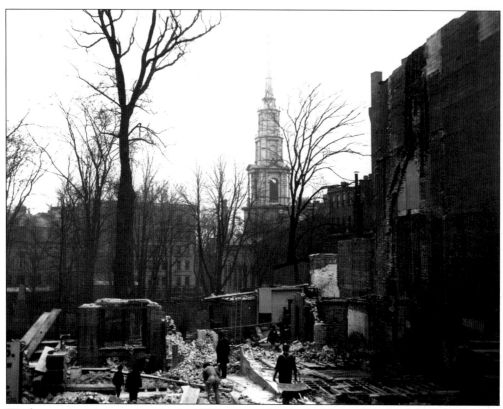

Workmen at a construction site in 1897 prepare for the building of the New Congregational House at 14 Beacon Street. Located to the right of the Boston Athenaeum, it houses offices of the Congregational Church of the United States, along with its extensive library and numerous nonprofit societies. (Courtesy of the Bostonian Society.)

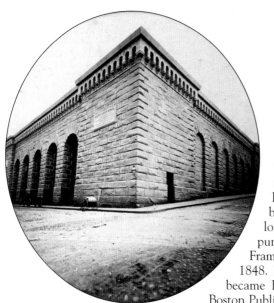

The Boston Water Works Beacon Hill reservoir sprawls over the top of Beacon Hill in this 1860 view. It was located behind the original statehouse, where the long addition now stands, and held water pumped from Lake Cochituate in Framingham, a source that was first tapped in 1848. In 1869, Upper Mystic Lake in Medford became Boston's water supplier. (Courtesy of the Boston Public Library; photograph by J.J. Hawes.)

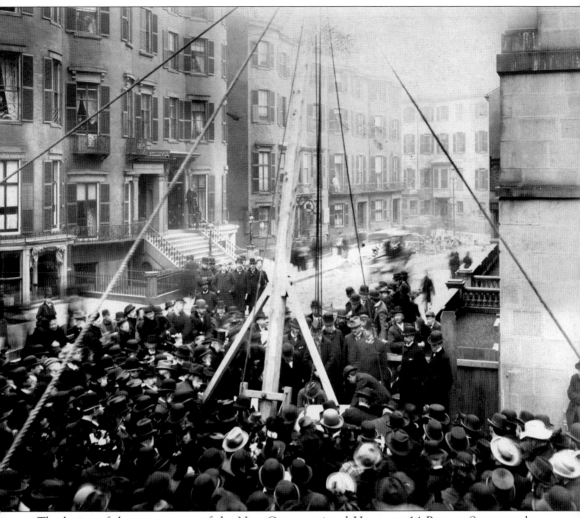

The laying of the cornerstone of the New Congregational House, at 14 Beacon Street, took place on November 29, 1897. The new building replaced the society's former location at 1 Somerset Street. (Courtesy of the Congregational Library.)

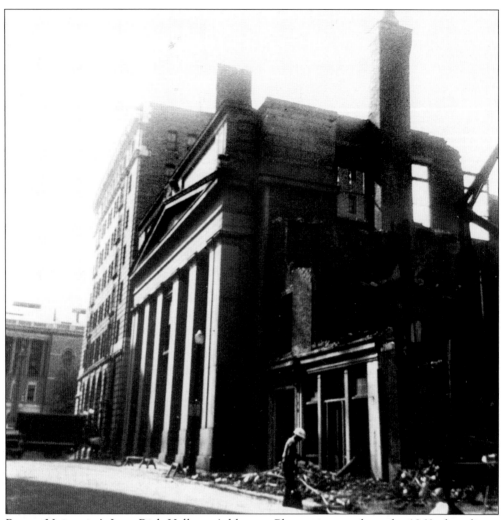

Boston University's Isaac Rich Hall, on Ashburton Place, witnesses here the 1960s demolition of its neighbor to the east. The Massachusetts State House extension is seen in the background. (Courtesy of the Bostonian Society.)

Eight

CULTURE AND
EDUCATION

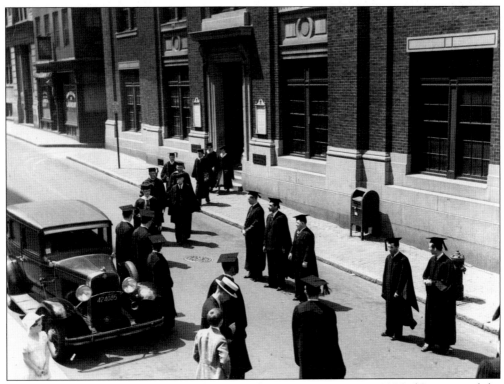

Students leave Suffolk Law School during graduation ceremonies in 1936. (Courtesy of the Suffolk University Archives.)

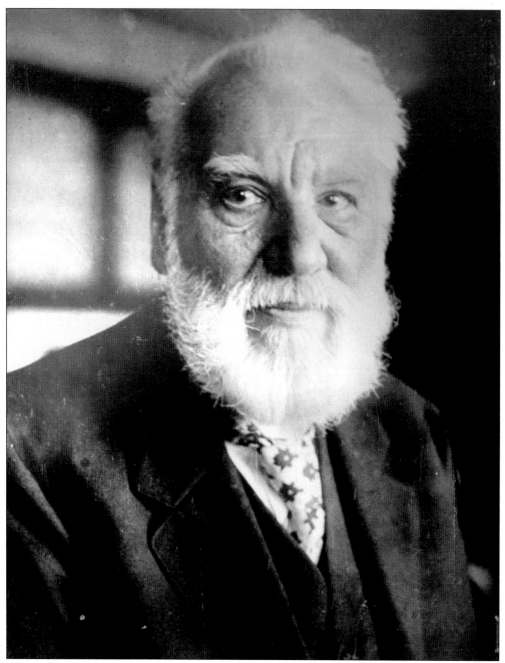

Alexander Graham Bell, the inventor of the telephone, did developmental work in sound transmission at Boston University's offices at 20 Beacon Street. He and his assistant, Watson, did their pioneering work in developing the telephone at nearby 109 Court Street. Bell and his wife were guests at the Hotel Bellevue opposite the Boston University building. (Courtesy of the Boston Public Library.)

Ralph Waldo Emerson, minister, lecturer, and author, although a Concord resident, had several ties with upper Beacon Hill. As an active member of the Transcendentalist movement, he was a friend and colleague of James Freeman Clarke, minister of Beacon Hill's Church of the Disciples. He was also a member of the Boston Athenaeum and spent many hours there with his reading lists. His tastes were wide, extending from Plato to the Bhagavad-Gita. Emerson also attended the small literary salon at the Hotel Bellevue. (Courtesy of the Boston Public Library.)

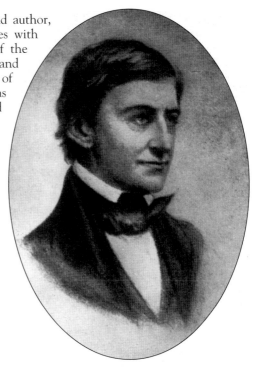

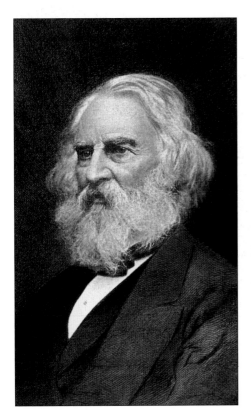

Henry Wadsworth Longfellow, poet and professor of modern languages, was born in Maine and attended Bowdoin College. He was a resident of Cambridge and a professor of French and Spanish at Harvard University. He is most remembered for his poems "Evangeline," "Hiawatha," "Tales of a Wayside Inn," and "The Midnight Ride of Paul Revere." Longfellow took part in the Hotel Bellevue's literary salon. (Courtesy of the Boston Public Library.)

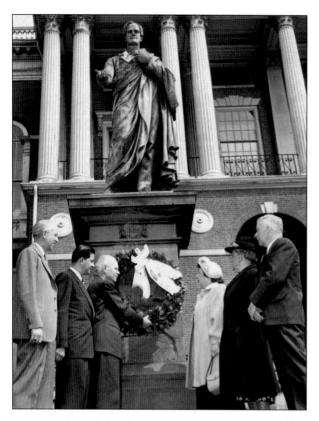

Horace Mann, whose statue can be found on the Massachusetts State House lawn, was a leading national educator. Born in Franklin in 1796, he became a Massachusetts senator and the first secretary of the Massachusetts State Board of Education. His accomplishments included forming America's first normal school for teachers in Lexington in 1839, advocating district school libraries, improving the quality of Massachusetts schools, and campaigning for public funding for schools. Schools named for this pioneer in education are to be found throughout the United States. In this photograph, Massachusetts educators place a wreath on his statue in honor of his birthday. (Courtesy of the Boston Public Library.)

The first office of the Society for the Preservation of New England Antiquities was located at 20 Beacon Street. The society's role in preservation and education places it among the country's leaders in that field. This small space is in marked contrast to the large quarters it now occupies in the Harrison Gray Otis House on Cambridge Street. (Courtesy of the Society for the Preservation of New England Antiquities.)

Julia Ward Howe was the composer of the Civil War song "The Battle Hymn of the Republic." The song was first sung by Civil War troops and soon became a national favorite. A member of upper Beacon Hill's Church of the Disciples, she was a lecturer on abolition and women's rights. (Courtesy of the Boston Public Library.)

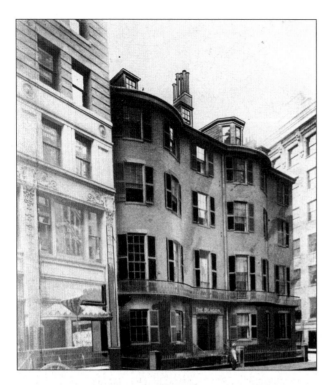

The Beacon, a Suffolk University building, was located at the corner of Beacon and Somerset Streets *c.* the 1890s. The site is now occupied by the Lawyer's Building. (Courtesy of the Suffolk University Archives.)

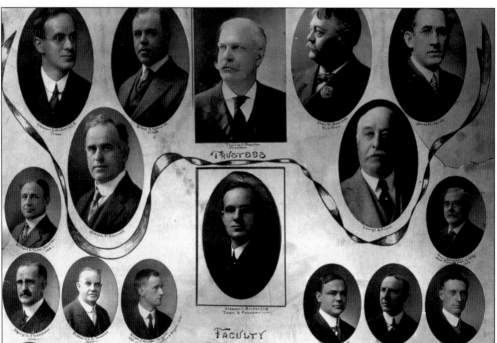

This photograph shows the faculty of the Suffolk Law School in 1916. In the center is the school's founder and president, Gleason Archer. He founded the school in 1906 to provide legal training for immigrants and working men. The school was originally an evening school—it became a university in 1936. (Courtesy of the Suffolk University Archives.)

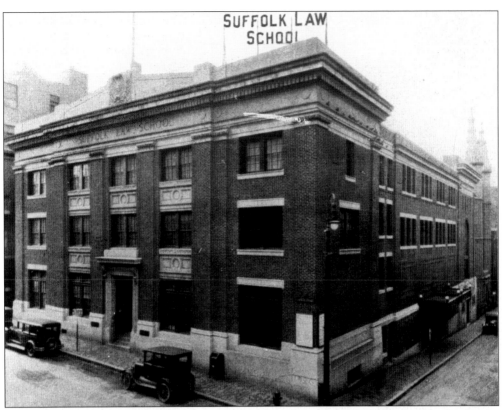

Suffolk Law School, on Derne Street, is pictured in the 1920s. The school attracts a diverse student body from varying ethnic and economic backgrounds. Suffolk University currently has the highest percentage of international students in the Northeast. It now offers programs in Spain, Africa, India, and Sweden. (Courtesy of the Suffolk University Archives.)

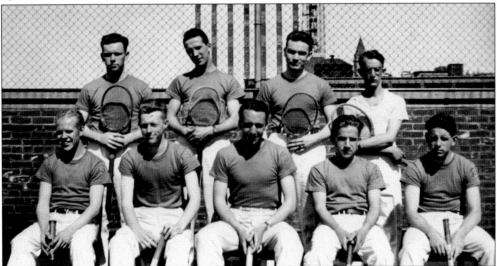

In this 1930s view, the Suffolk University men's tennis team poses on the rooftop of Suffolk Law School's Archer building. Lacking funds for tennis courts, the school ingeniously used netting seen in the background to curb stray tennis balls. (Courtesy of the Suffolk University Archives.)

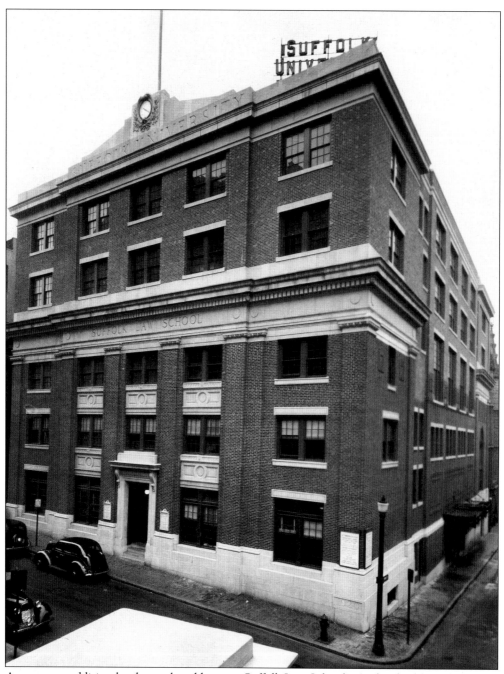

A two-story addition has been placed here on Suffolk Law School's Archer building. (Courtesy of the Suffolk University Archives.)

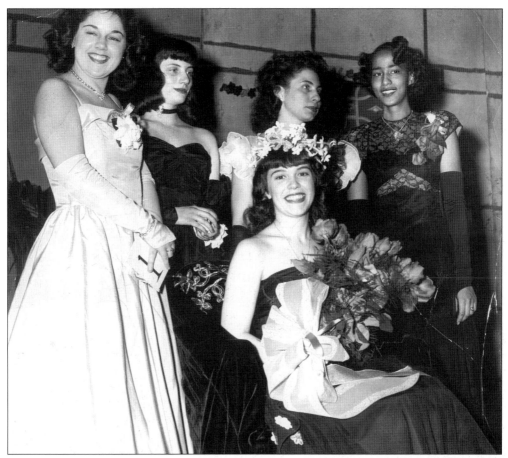

This 1949 photograph shows the smiling winner of the Miss Suffolk contest. (Courtesy of the Suffolk University Archives.)

Suffolk students are shown on the Boston Common. (Courtesy of the Suffolk University Archives.)

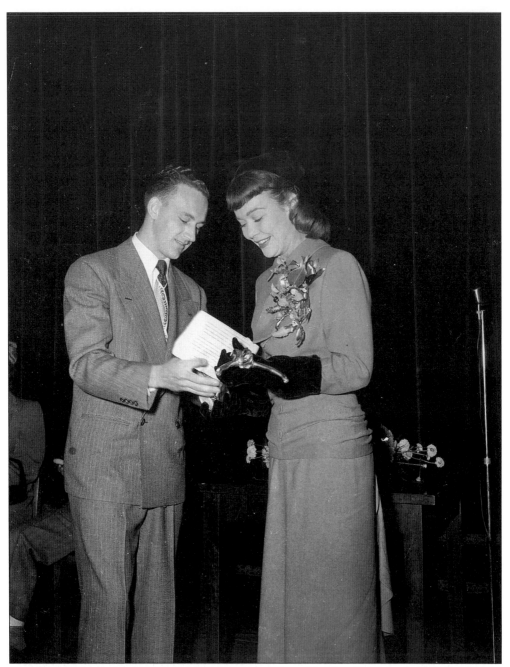

Actress Jane Wyman receives a Suffolk University "Oscar" in this 1948 photograph for her role in *Johnny Belinda*, which had its Boston premiere in Suffolk's C. Walsch Theater. Since Suffolk students correctly predicted Wyman's Academy Award Oscar for her role in the film and also predicted Pres. Harry Truman's victory in the 1948 presidential election, Wyman sent the following telegraph to Suffolk University: "Suffolk University must possess the powers of a seer. [They] predicted the outcome of last November's election and now they have established something like a new record in picking the winner of the Oscar months in advance." (Courtesy of the Suffolk University Archives.)

Nine

CHURCHES

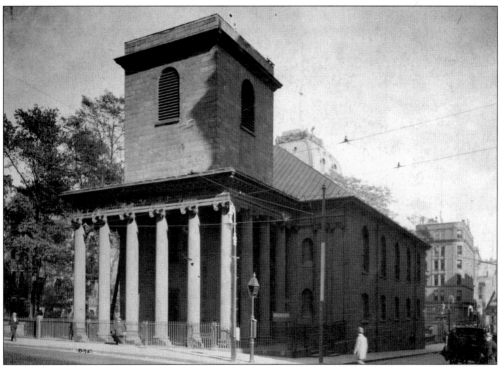

King's Chapel, the first Anglican church in Boston, was founded in 1686 and initially occupied a small, wooden frame structure at the corner of present-day Tremont and School Streets. The existing structure, designed by Rhode Island architect Peter Harrison and built on the same site between 1749 and 1754, was intended to include a stately spire atop the tower, but funds ran out and the spire was never constructed. In 1789, it became the first Unitarian church in America. (Courtesy of the Boston Public Library.)

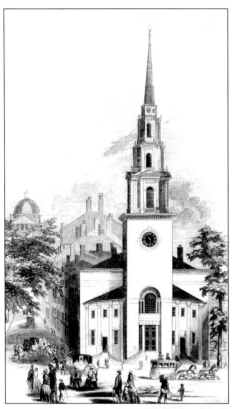

Peter Banner's 1810 Park Street Church, built on the site of a 1738 granary, boasts a steeple in the style of Christopher Wren. Here, William Lloyd Garrison gave the first abolitionist speech in the nation, and the song "America" was first sung. The area, known for the expressiveness of its ministers' sermons, was called Brimstone Corner. In keeping with the early church's reputation for evangelism and missions, the current Park Street Congregational Church maintains an active worldwide ministry. (Courtesy of the Boston Athenaeum.)

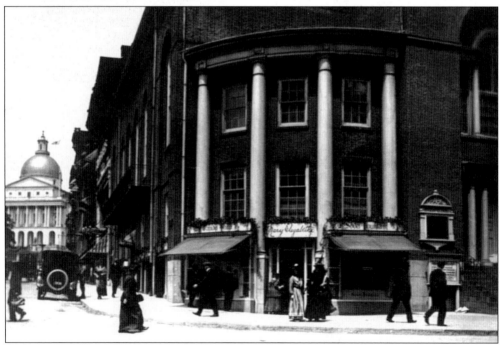

The corner of Park and Tremont Streets shows the front of Park Street Church, which is surprisingly the scene of the Mary Elizabeth Shop. (Courtesy of Dr. Michael C. Stone.)

An aerial view of Park Street Church gives a detailed view of its fine Christopher Wren–design steeple. (Courtesy of Dr. Michael C. Stone.)

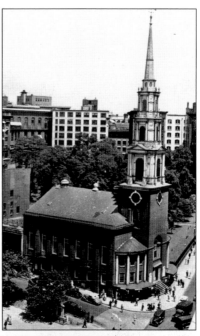

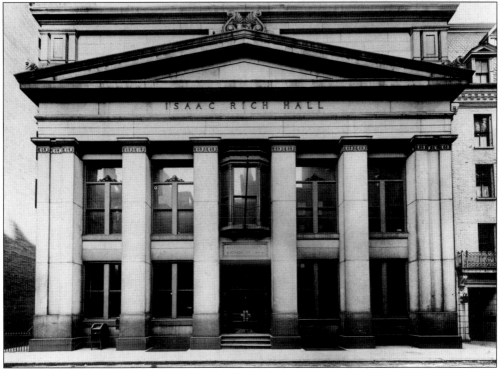

Isaac Rich Hall, a dignified example of 19th-century Greek Revival architecture, is shown here in a 1921 photograph. The classical columns of this Greek temple–front building are topped by a pediment, or triangular cap, over the building's entrance. The Mount Vernon Church, built in 1842, originally occupied the site, which was used by Boston University at the time of the photograph. (Courtesy of the Society for the Preservation of the New England Antiquities.)

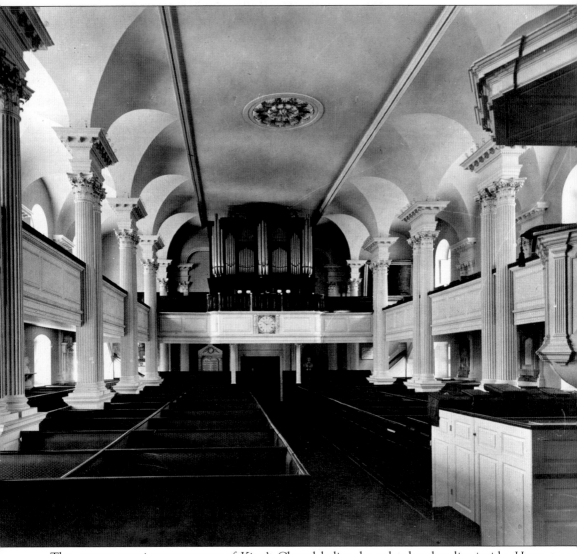

The austere exterior appearance of King's Chapel belies the splendor that lies inside. Here, paired Corinthian columns gracefully line the nave, and a striking richness and brightness permeates the voluminous space. Congregations continue to worship here today as they have for more than two centuries. (Courtesy of the Boston Public Library.)

This 1853 glass negative includes King's Chapel and its neighbors on Tremont Street—the Parker House and the Boston Museum, which stands to the left of the Parker House. (Courtesy of the Boston Public Library.)

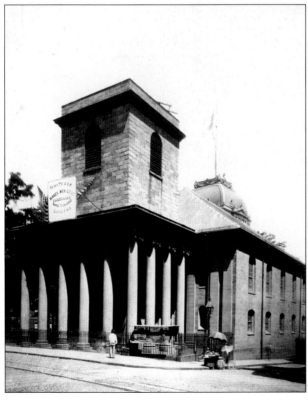

This view of King's Chapel, or Stone Chapel, as it was also called, was taken on July 4, 1870, for the celebration of the national centennial. The sign above the church entrance reads, "Whatever makes men good Christians, makes them good citizens." Note Tremont Street's cobblestones. (Courtesy of the Boston Public Library.)

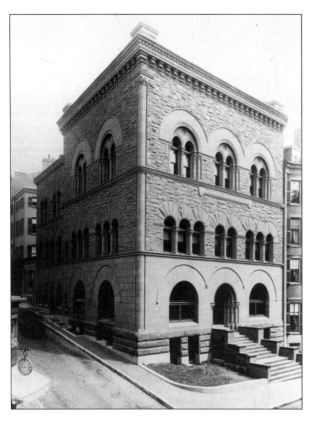

This Romanesque building located at 25 Beacon Street on the corner of Bowdoin Street, was the home of the American Unitarian Association. Located on the site of former governor James Bowdoin's mansion, it was the administrative center for Unitarian activities across the country. When the building was razed in the 1920s, the west portion of the Hotel Bellevue, by the architectural firm of Putnam and Cox, was built on the site. The Unitarian association took the number 25 with it when it relocated on Beacon Street just below the Massachusetts State House, to the dismay of many mail carriers. City Convenience and the Beirut Restaurant now occupy the ground floor of the current Putnam and Cox building. (Courtesy of Society for the Preservation of New England Antiquities; photograph by Soule.)

The community's large concentration of churches and its nearness to the harbor attracted diverse messengers of new religious thought. Shown here is a 1920s photograph of Swami Paramahansa Yogananda, who arrived in Boston to speak at the International Congress of Religious Liberals in 1920, sponsored by the American Unitarian Association in Boston. Yogananda brought with him India's ancient science of yoga, which was applicable to the current needs of the times. He could be seen almost daily striding up Park Street to visit the Unitarian offices at 25 Beacon Street in his striking ochre robe and turban. Following lecture series in such Boston locations as Symphony Hall and Harvard, and lecture tours throughout the country, he established the Self-Realization Fellowship International Headquarters in Los Angeles in 1925. (Courtesy of the Self-Realization Fellowship International Headquarters Archives, Los Angeles.)

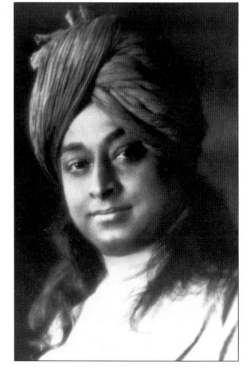

Grace Church, seen in this *c.* 1860 photograph, was located on Temple Street. It was originally founded in 1836 as the Temple Street Church. (Courtesy of the Boston Public Library; photograph by J.J. Hawes.)

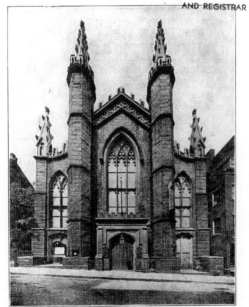

FIRST CHURCH HERALD
Historic Illustrated Edition DESK COPY
VOLUME 2 EXECUTIVE SECRETARY
~~AND REGISTRAR~~

FIRST METHODIST EPISCOPAL CHURCH
TEMPLE STREET, BOSTON
PUBLISHED IN COMMEMORATION OF
The One Hundredth Anniversary
OF THE ERECTION OF TEMPLE STREET CHURCH
DECEMBER 6-13, 1936

The First Methodist Episcopal Church occupies the former Grace Church on Temple Street. It was a common practice during this period for churches to move frequently. As new, more desirable areas of Boston were developed, almost the entire parish of a church might move to the new locale and build a new church there or find a vacant church in which to relocate. A kind of church musical chairs was in operation. Here, the First Methodist Episcopal Church celebrates in December 1936 the 100th anniversary of the founding of Temple Street Church. (Courtesy of the Suffolk University Archives.)

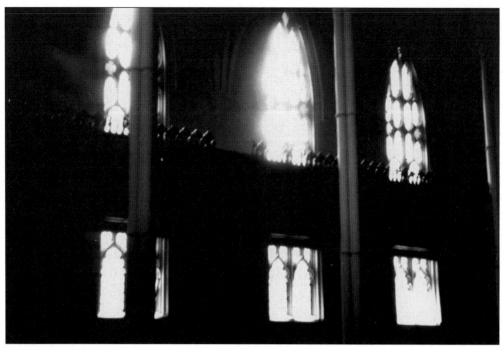

This photograph shows the interior of the Church of the New Jerusalem as it was in 1964 before the church's demolition. (Courtesy of the Bostonian Society.)

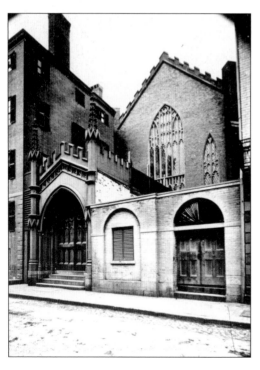

The Gothic-style Swedenborgian Church of Boston, or Church of the New Jerusalem, was one of the earliest Swedenborgian churches in America. It was built in 1845 at the top of Beacon Hill at 140 Bowdoin Street. The Swedenborgian philosophy is based on the visions and writings of Emmanuel Swedenborg, an 18th-century Swedish theologian and scientist. The neighborhood's strong tie to the sea is illustrated by the fact that this philosophy was introduced to Boston by the Scotsman John Glen, who was converted to Swedenborgianism by the captain of the ship carrying him from South America to Boston. (Courtesy of the Boston Athenaeum; photograph by J.J. Hawes.)

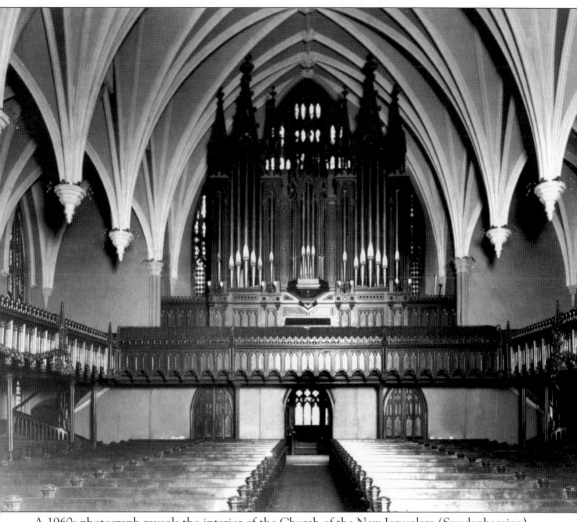

A 1960s photograph reveals the interior of the Church of the New Jerusalem (Swedenborgian) and its organ. (Courtesy of the Society for the Preservation of New England Antiquities.)

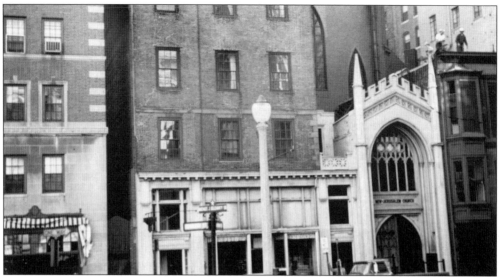

The Church of the New Jerusalem (Swedenborgian) was formed in 1818 with 12 members. One of its original founders, Thomas Worcester, found Swedenborg's teachings while a student at Harvard and was the society's pastor for 49 years. The original church was constructed on Bowdoin Street in 1845. This photograph was taken in September 1964 just before demolition of the building began in order to create a new church center. Apartments built above the church facilitate the society's financial support. (Courtesy of the Bostonian Society.)

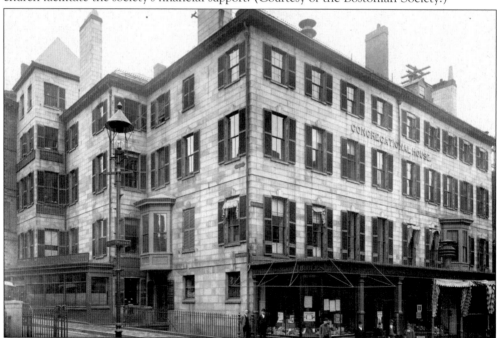

The Old Congregational House, at the corner of Beacon and Somerset Streets, housed most of the benevolent societies with offices in Boston—societies to which the Congregational House made regular contributions. It also housed the Congregational Library. Three floors of the building were used by the Roxbury Carpet Company. Weekly and monthly periodicals pertaining to the work of the church were printed here. (Courtesy of the Congregational Library.)

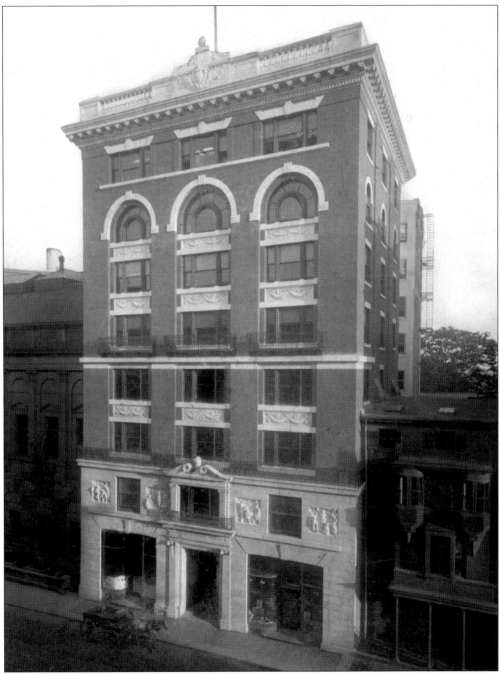

The Congregational House, designed by architects Sheply, Rutan, and Coolidge, is the home of Congregationalism and is a repository not only of rooms and books, but also of the history of Congregationalists in New England. The institution had a role in the social movements of the early 20th century and houses the offices of many religious and nonprofit associations, which directly affect people in need throughout Boston and the state of Massachusetts. The building's Congregational Library contains an extensive collection of books and periodicals. Books were sent overseas for the use of chaplains in World War II. (Courtesy of the Congregational Library.)

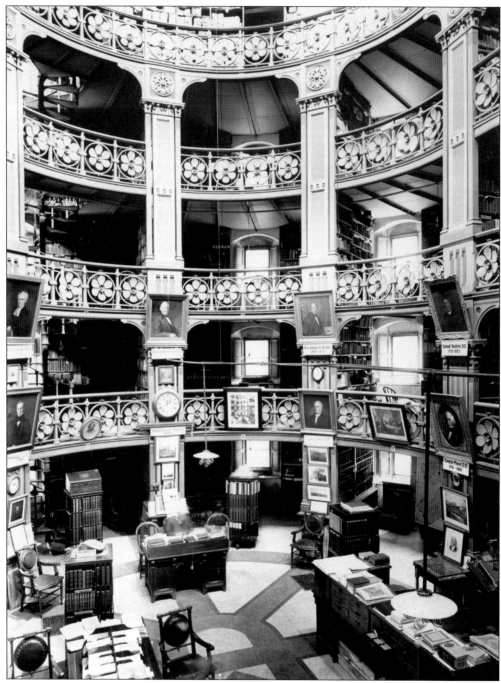

The vastness of the Congregational Library at the Old Congregational House, at Beacon and Somerset Streets, gives an indication of the enormous scope of the church's activities at this time. A lending library was maintained here. (Courtesy of the Congregational Library.)

The Bowdoin Square Baptist Church, pictured c. 1860, was built in 1840 with a front of unhammered granite. Its tower is 28 feet square and 100 feet high. (Courtesy of the Boston Public Library; photograph by J.J. Hawes.)

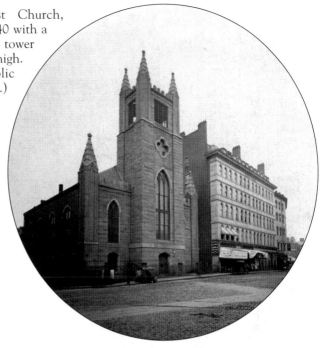

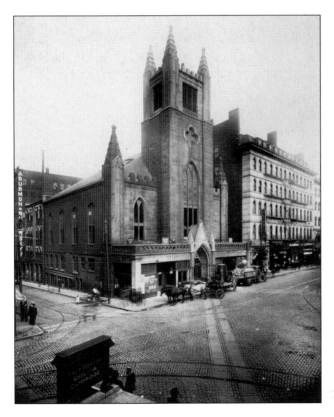

In this 1915 photograph, the Bowdoin Square Baptist Church, formerly the Lyman Beecher Congregational Church, has acquired additions to its lower front facade. The streetcar tracks indicate an area of high traffic. (Courtesy of the Boston Public Library.)

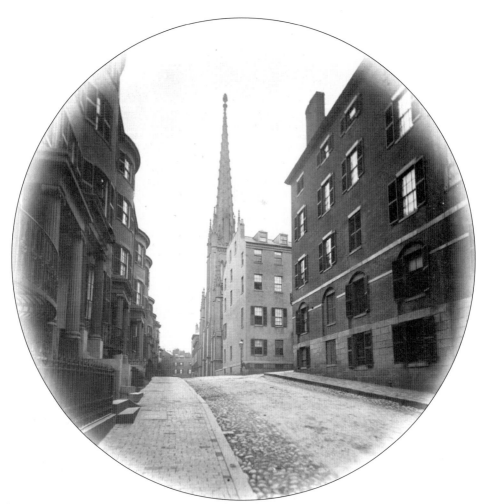

The 200-foot spire of the Somerset Street Baptist Church rises on the crest of Somerset Street. The church was built in 1858 of brick with a stucco front. After the church joined with the Shawmut Avenue Baptist Church, it left the site, which was later occupied by the First Free-Will Baptist Church. In 1882, Boston University purchased the Somerset church, and Jacob Sleeper Hall was erected on the site. The location is currently the scene of the construction of a Suffolk University dormitory. (Courtesy of the Boston Public Library; photograph by J.J. Hawes.)

Ten
STREET SCENES
AND ECCENTRICITIES

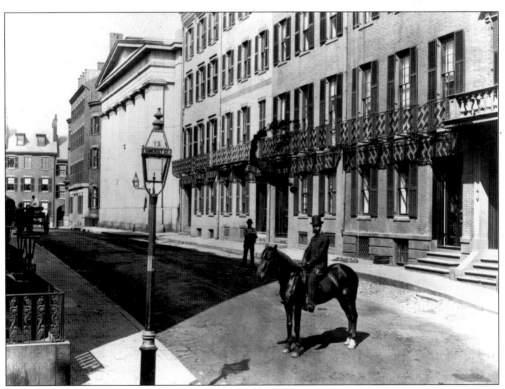

A bowler-topped equestrian adds distinction to Ashburton Place in this mid-1800s photograph, taken near the corner of Somerset Street. Cast-iron balconies at the second-floor level underline the importance of this floor, marked also by its larger windows. (Courtesy of the Society for the Preservation of New England Antiquities; photograph by Baldwin Coolidge.)

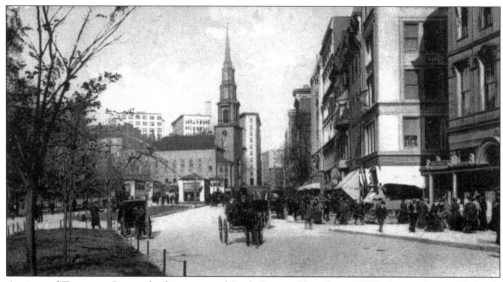

A view of Tremont Street, looking toward Park Street Church in 1905, shows the newly built Park Street Station for the Underground Transit System. (Courtesy of Dr. Michael C. Stone.)

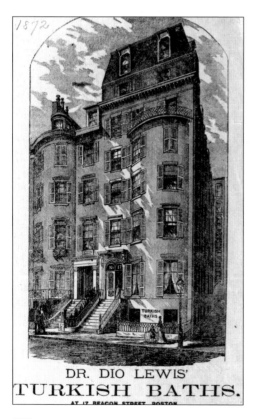

In 1858, gymnast Dr. Dio Lewis opened the bowfront Hotel Bellevue as a temperance hotel at 17 Beacon Street. Following a 19th-century trend, he installed Turkish baths in the building's basement and operated the hotel as an alcohol-free, vegetarian establishment. Louisa May Alcott, a guest who wintered at the Bellevue, discussed homeopathy, temperance, and Roman baths with Lewis. The Bellevue's resemblance to current health spas is striking. (Courtesy of the Bostonian Society.)

106

Shown here is a broadside by the Hotel Bellevue's owner, Dr. Dio Lewis, citing the excellence of the hotel's turkish baths. The 20th-century Hotel Bellevue's lively Bellevue Bar made a decided contrast to Lewis's establishment. (Courtesy of the Bostonian Society.)

Dr. Dio Lewis'
Turkish Baths
17 Beacon St. Boston

These baths are the
finest in America
and superior in
Cleanliness and
Ventilation to the
very best of ^the 400
Turkish Baths
in Great Britain.

Catarrh, rheumatism
torpid liver, and general
dulness are quickly relieved

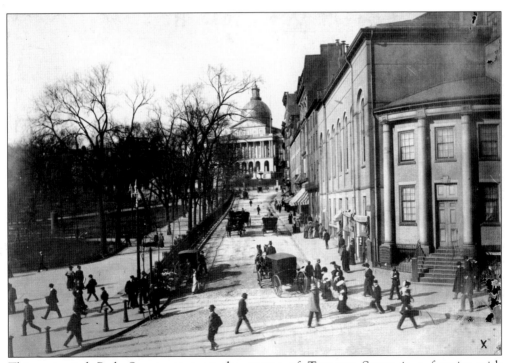

This animated Park Street scene at the corner of Tremont Street is a favorite with photographers for its compelling view of the Massachusetts State House. (Courtesy of the Boston Public Library.)

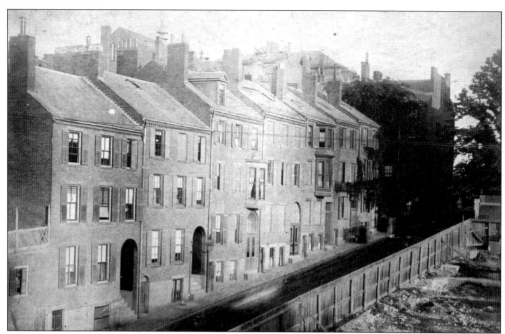

An 1860 photograph places Temple Street from Derne Street to Mount Vernon Street in view. (Courtesy of the Boston Public Library.)

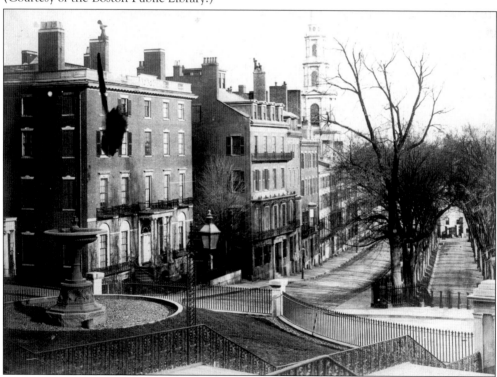

Another photographer's favorite is this view of Park Street, looking toward the Park Street Church. On the left is the Amory-Tichnor house, built in 1803–1804. To its right, separated by three houses, is the Park Row, built in 1803–1805. (Courtesy of the State Library of Massachusetts.)

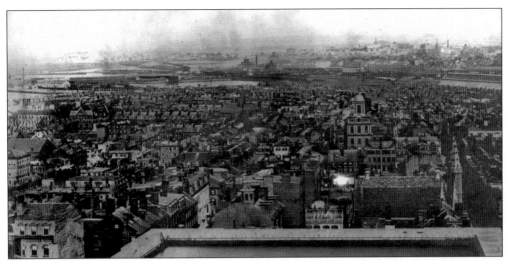

An aerial view from the Massachusetts State House shows the top of the Beacon Hill reservoir in the foreground. The north slope of Beacon Hill stretches down to the Charles River. The Old West Church, on Cambridge Street, is shown in the center of the photograph. In the background, to the right, is the Boston and Lowell Railroad Station, located in the area of the present North Station. (Courtesy of the Bostonian Society.)

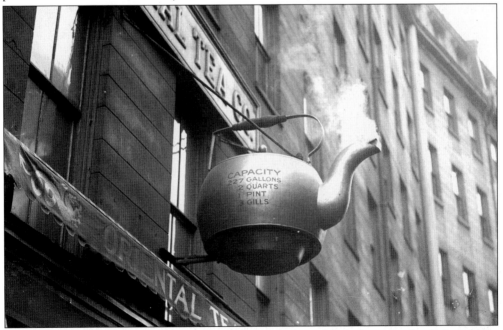

A Scollay Square tourist mecca was the steaming brass teakettle hung by the Oriental Tea Company in 1875. Used as a sign at the Court Street store, it attracted great attention when it was installed—12,000 people registered to guess the kettle's capacity. On the day the winner was to be announced, throngs of people crowded Court Street with horse carts and teams to hear the answer. The right guess was 227 gallons, 2 quarts, 1 pint, and 3 gills. The kettle was moved frequently as buildings were demolished to construct the Government Center. It now rests over the entrance to Starbucks at the top of Court Street. (Courtesy of the Boston Public Library; photograph by Leslie Jones.)

A 1927 photograph shows Tremont Street near Park street. (Courtesy of the Boston Public Library.)

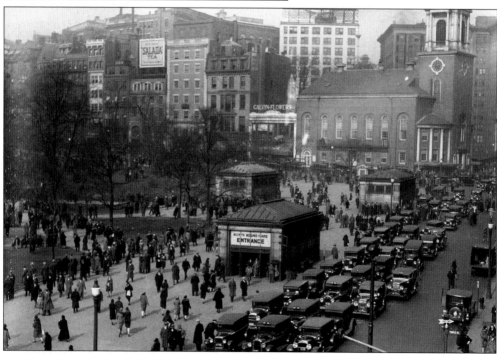

Traffic jams on Tremont Street near Park Street were not uncommon in the early 1900s. A local wag said that hopping from the roof of one car to the next was the fastest way to get down Tremont Street at rush hour. (Courtesy of the Boston Public Library; photograph by Leslie Jones.)

The crowd scene in this 1927 photograph was typical at the corner of Park and Tremont Streets. (Courtesy of the Boston Public Library.)

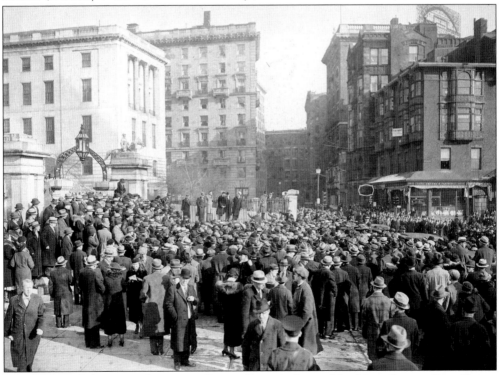

Another crowded spot was the area on Beacon Street in front of the Massachusetts State House. (Courtesy of the Boston Public Library; photograph by Leslie Jones.)

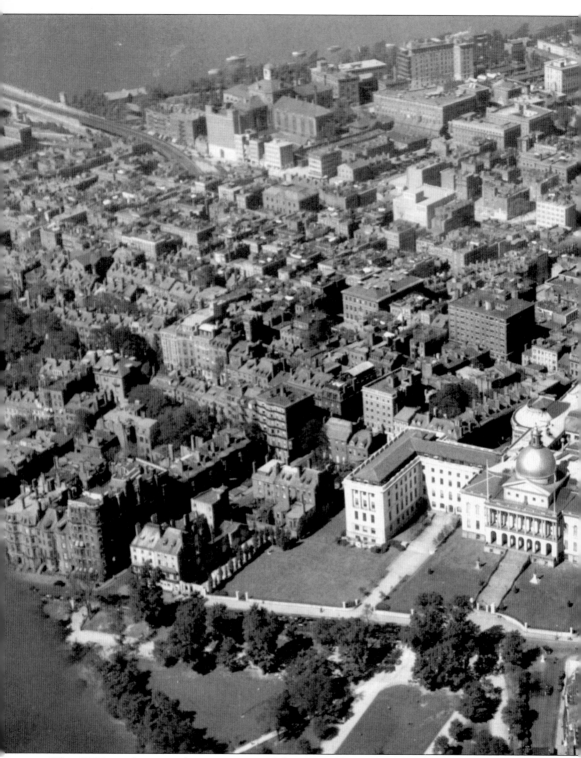

This 1925 aerial view outlines a portion of the geographic scope of upper Beacon Hill. In the center is the Massachusetts State House, with Beacon Street and the Boston Common in front.

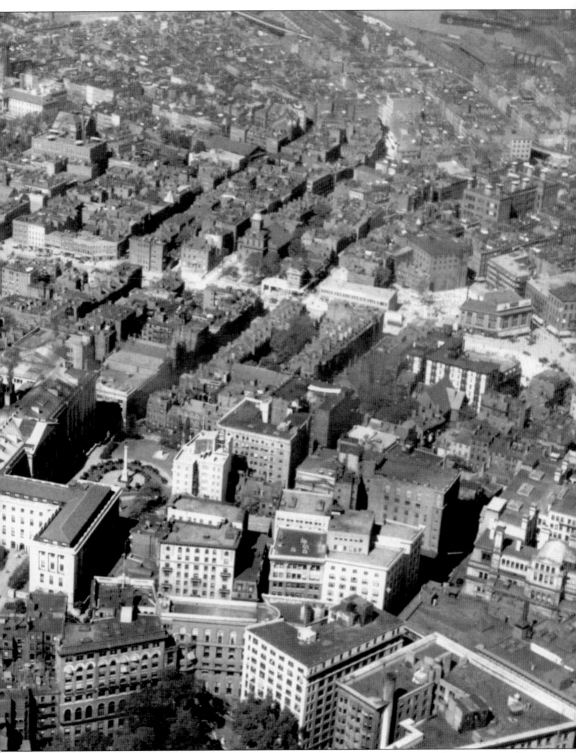

Running from the bridge across the Charles River is Cambridge Street, which cuts across the photograph at an angle. (Courtesy of the Boston Public Library.)

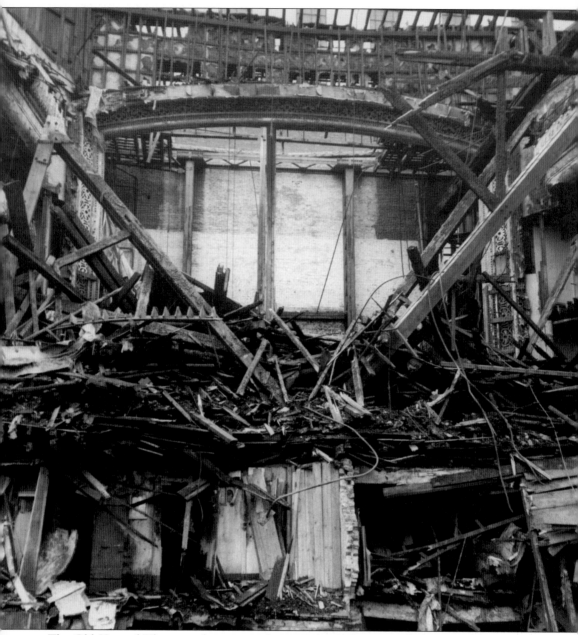

The Old Howard Theater is being torn down in the 1960s prior to the construction of the Government Center. Parts of the first balcony remain in view—a proud vestige of former happy times. This picture ran in the *Boston Herald*. (Courtesy of the Boston Public Library.)

A 1905 postcard view shows the Massachusetts State House with the statue of Colonel Hooker in the foreground. The center Bulfinch portion is painted white. (Courtesy of J.V. Weston.)

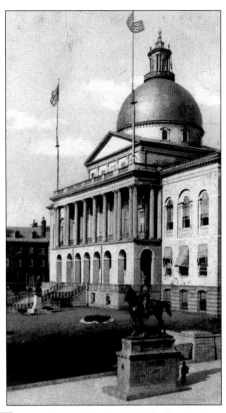

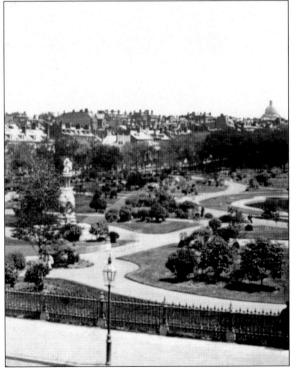

A distant view of the Boston Common from Arlington Street includes the distant Massachusetts State House and tall spire of the First Baptist Church on Somerset Street. (Courtesy of Dr. Michael C. Stone.)

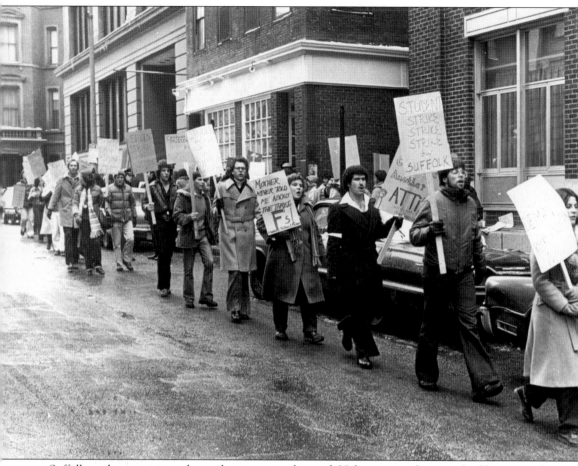

Suffolk student activists take to the streets in this mid-20th-century photograph. (Courtesy of the Suffolk University Archives.)

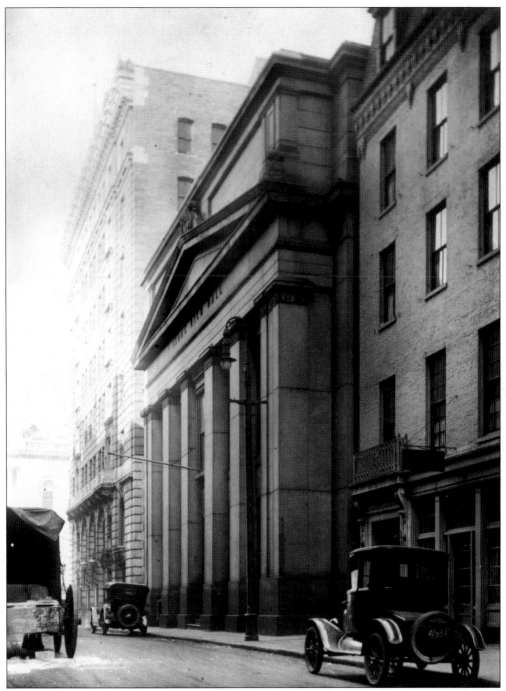

The early Ford cars shown on Ashburton Place in this 1921 photograph are a growing, sleek replacement in urban Boston for the horse-drawn cart on the left. Boston University's Isaac Rich Hall Law School, an example of Greek temple style, is in the center of the picture. (Courtesy of the Society for the Preservation of New England Antiquities; photograph by Halliday.)

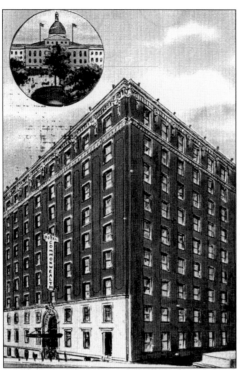

A 1940s postcard reveals the Hotel Commonwealth at 86 Bowdoin Street. Its nearness to the Massachusetts State House, reasonable rates (rooms with hot and cold water $1.25 and up), and access to the Bowdoin Square garage made it a popular place to stay. (Courtesy of J.V. Weston.)

The arched side windows of the American Unitarian Association building are barely visible in the lower right of this early-1900s bird's-eye view of upper Beacon Hill. Directly opposite the front of the Unitarian building is the front facade of the Boston Athenaeum. (Courtesy of Dr. Michael C. Stone.)

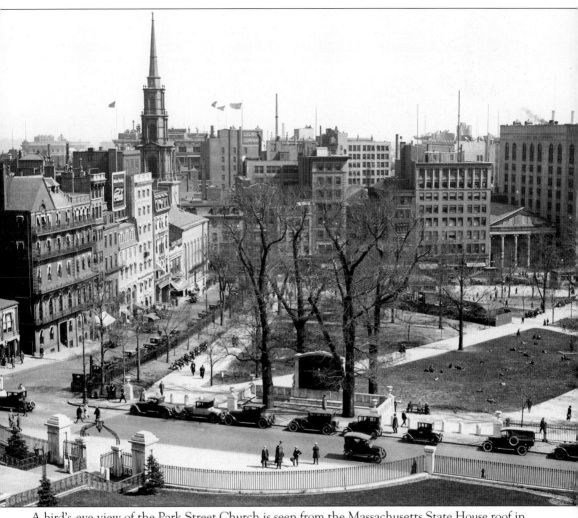

A bird's-eye view of the Park Street Church is seen from the Massachusetts State House roof in 1924. (Courtesy of the Boston Public Library.)

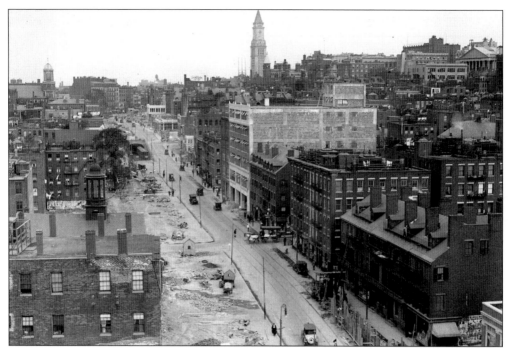

Cambridge Street is undergoing a widening in the 1920s. The customs house tower is seen on the horizon in the center of the photograph. (Courtesy of the Boston Public Library; photograph by Leslie Jones.)

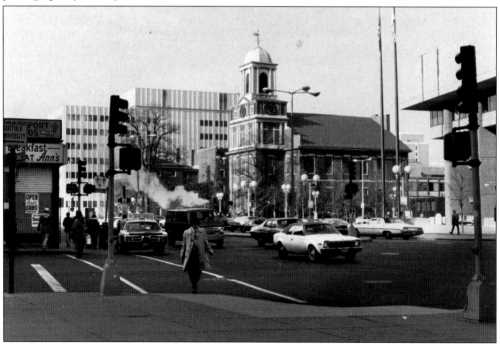

Scollay Square shows its mixture of the old and the new. Old West Church, built in 1806 by Asher Benjamin, vies with Paul Rudolph's Lindeman Center on the right and the square's ever-present sub shop and passport photograph signs. (Courtesy of the Suffolk University Archives.)

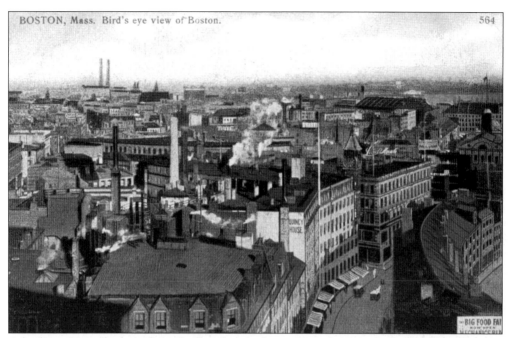

A bird's-eye view looking from Scollay Square down Court Street reveals Faneuil Hall at the end of the street. (Courtesy of Dr. Michael C. Stone.)

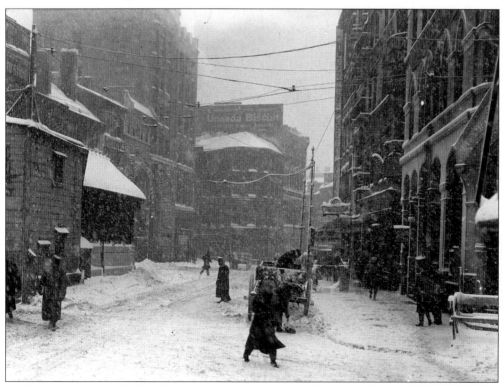

In this photograph, Scollay Square sees the results of the city's biggest blizzard to date. (Courtesy of the Boston Public Library.)

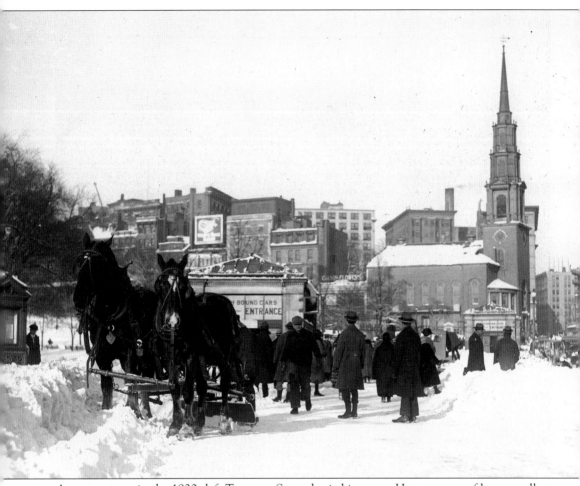

A severe storm in the 1920s left Tremont Street buried in snow. Here, a team of horses pulls a plow to clear the way. (Courtesy of the Boston Public Library; photograph by Leslie Jones.)

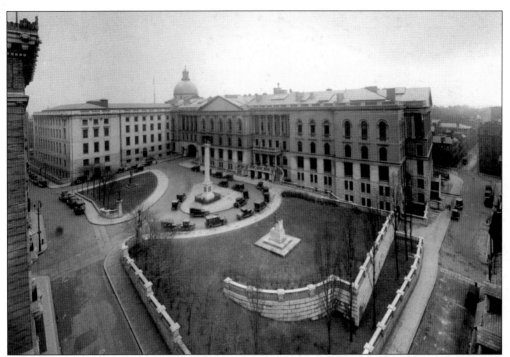

The Massachusetts State House extension and driveway are seen in this 1920s view. Bowdoin Street is on the left, and Derne Street is on the right. (Courtesy of the Boston Public Library.)

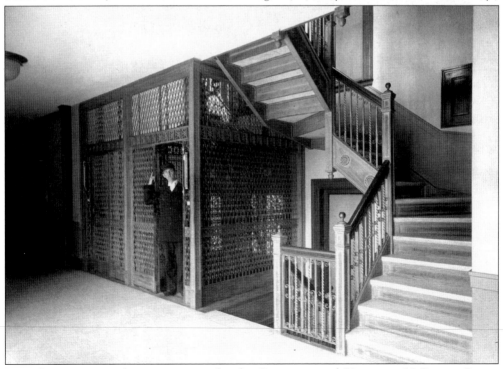

James Lawrence, an elevator operator for the Congregational House, at 14 Beacon Street, beckons to his next passenger in this c. 1930s image. (Courtesy of the Congregational Library.)

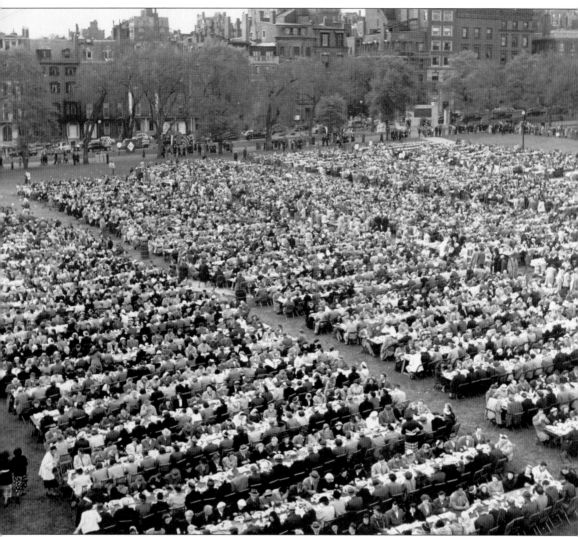

More than 1,000 people are gathered on the Boston Common for the Unitarian-Universalist 1950 Boston Jubilee baked bean supper. The original national office of the American Unitarian Association was at 25 Beacon Street, located at the corner of Beacon and Bowdoin Streets. (Courtesy of the Boston Public Library.)

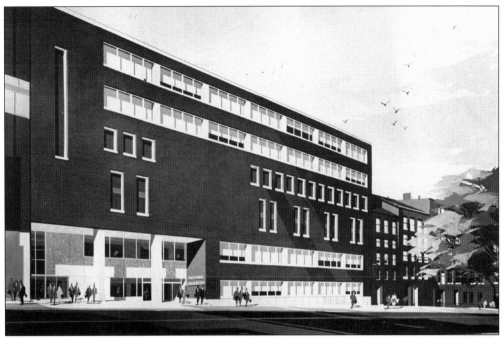

An artist's rendition in 1964 shows the proposed seven-story addition for Suffolk University at 41 Temple Street, later named the Donahue building. Its cost was $3 million. (Courtesy of the Boston Public Library.)

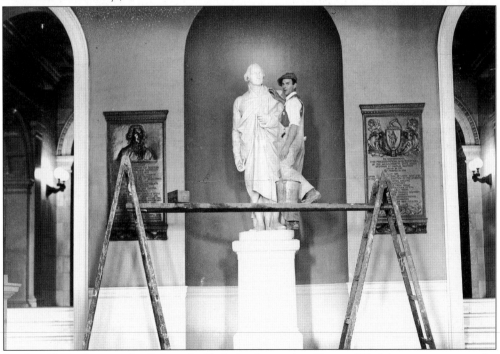

In this 1932 photograph, Robert J. Guthrie cleans the George Washington statue at the Massachusetts State House in preparation for the celebration of the bicentennial of Washington's birth. (Courtesy of the Boston Public Library; photograph by Leslie Jones.)

Ashburton Park, a historic reclamation, can be found behind the Massachusetts State House's east wing. Enjoyed by statehouse occupants and visitors, it is also the scene of state functions. A 1980s decision removed the site's former parking lot and provided for an underground parking garage, leaving open space above for a park. Ashburton Park, named for the street perpendicular to it, and the garage were completed in 1991. (Courtesy of the State Library of Massachusetts.)

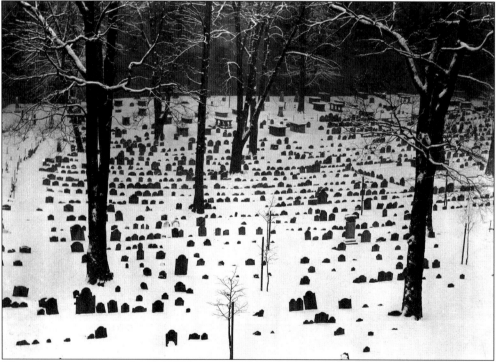

The calm winter scene of the old Granary Burying Ground, established in 1660, is viewed from its Tremont Street entrance. It contains the graves of Paul Revere, Benjamin Franklin's parents, and Elizabeth Vergoose, supposed author of the Mother Goose rhymes. The large vaults in the rear belong to wealthier families. Among them are the graves of the Faneuils, a family of Huguenots, or French Protestants. This rare pocket of silence in the middle of Tremont Street's urban activity is one of the neighborhood's gifts. (Courtesy of the Boston Athenaeum.)

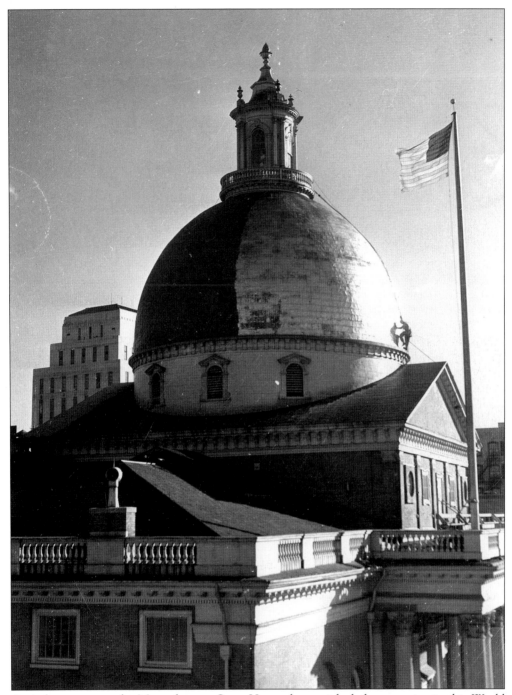

A workman covers the Massachusetts State House dome with dark-gray paint in this World War II photograph. Key civilian and military locations were camouflaged during the war to avoid detection by enemy aircraft. (Courtesy of the Boston Public Library.)

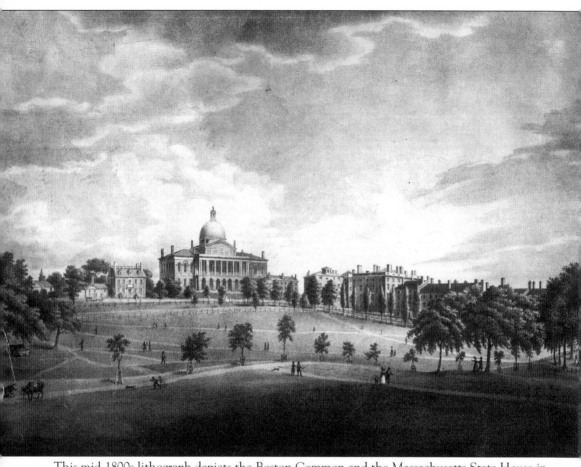

This mid-1800s lithograph depicts the Boston Common and the Massachusetts State House in the rural setting of the period. Gov. John Hancock's house is to the left of the statehouse, and the large Amory-Tichnor house, with its many chimneys, is to its right. (Courtesy of the State Library of Massachusetts.)